WORLD
FILM
LOCATIONS
FLORENCE

Edited by Alberto Zambenedetti

First Published in the UK in 2014 by
Intellect Books, The Mill, Parnall Road,
Fishponds, Bristol, BS16 3JG, UK

First Published in the USA in 2014
by Intellect Books, The University of
Chicago Press, 1427 E. 60th Street,
Chicago, IL 60637, USA

Copyright ©2014 Intellect Ltd

Cover photo: *A Room With A View*
(1986) ©Merchant Ivory/Goldcrest /
The Kobal Collection

Copy Editor: Emma Rhys

A Catalogue record for this book is
available from the British Library

World Film Locations Series
ISSN: 2045-9009
eISSN: 2045-9017

World Film Locations Florence
ISBN: 978-1-78320-360-4
ePDF ISBN: 978-1-78320-344-4

Printed and bound by
Bell & Bain Limited, Glasgow

WORLD FILM LOCATIONS
FLORENCE

EDITOR
Alberto Zambenedetti

SERIES EDITOR & DESIGN
Gabriel Solomons

CONTRIBUTORS
Eleanor Andrews
Stefano Ciammaroni
Marie-France Courriol
Nathaniel J. Donahue
Natalie Fullwood
Barbara Garbin
Brendan Hennessey
Danielle Hipkins
Dom Holdaway
Pasquale Iannone
Charles L. Leavitt IV
Ellen Nerenberg
Joseph Perna
Marco Purpura
Dana Renga
John David Rhodes
Monica Seger
Luca Somigli
Sara Troyani
Roberto Vezzani

LOCATION PHOTOGRAPHY
Alberto Zambenedetti, Elizabeth
Williams and Valeria Castelli

LOCATION MAPS
Greg Orrom Swan

PUBLISHED BY
Intellect
The Mill, Parnall Road,
Fishponds, Bristol, BS16 3JG, UK
T: +44 (0) 117 9589910
F: +44 (0) 117 9589911
E: *info@intellectbooks.com*

Bookends: View from Piazzale Michelangelo
(Alberto Zambenedetti)
This page: *Under the Tuscan Sun* (Kobal)
Overleaf: *Romola* (Kobal)

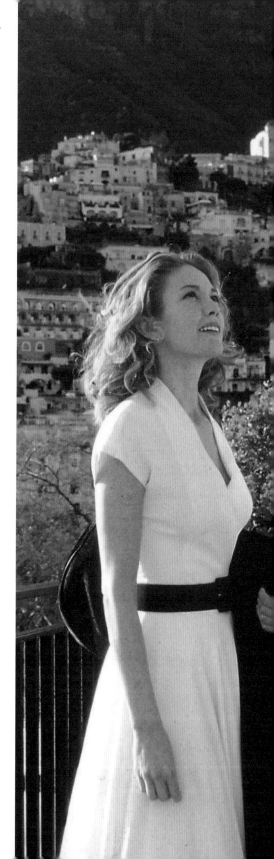

CONTENTS

DEDICATION AND
ACKNOWLEDGEMENTS

This book is dedicated to my wife
Denise Birkhofer, indefatigable work
partner and caring life companion.
I wish to thank all the wonderful
contributors to this volume, who with
their brilliant scholarship helped shape
my proudest editorial achievement
to date. I am also grateful to the
series editor Gabriel Solomons for his
guidance and assistance at every turn,
and to Emma Rhys for her meticulous
proofreading. Credit is also due to my
good friends and colleagues Elizabeth
Williams and Valeria Castelli, who
generously sprang into action when
location photos were needed.

ALBERTO ZAMBENEDETTI

INTRODUCTION

World Film Locations Florence

*The afternoon
goes away.
The sunset approaches,
a stupendous moment,
the sun goes away (to bed)
it is already evening all is over.*

THIS POEM, titled 'The Sunset', was written by 9-year-old Nadia Nencioni on 24 May 1993. On 27 May, the explosion of a car bomb parked by Florence's Torre dei Pulci caused the death of nine people. Nadia was among the victims of this despicable attack orchestrated by the mafia. The city laid a plaque, engraved with her poem, to commemorate the massacre of Via dei Georgofili. Forever memorialized in stone, Nadia's unforgettable verses are quite possibly the sincerest celebration of Florence ever committed to the page. Their extraordinary power stems from the love of a child for the exceptional light that bathes her city every day at magic hour. Her timeless words perfectly encapsulate the warm pink and orange hues colouring the sky over Florence as the sun travels west, toward the beaches of Livorno and Viareggio. The buildings on the north shore of the Arno River – those illustrious palaces and churches with their majestic towers and prodigious domes – glow resplendently in the last moments of the day, until the city finally begins to cool down, lulled by the deep blues of the fresh Tuscan night. Generations of artists, including film-makers, have worked with this unique light, trying to capture its ineffable beauty, the subtleties of its palette and to harness its power to elevate their art.

This volume is a collection of essays and descriptions of movie scenes written by some of the finest contemporary scholars of cinema. By no means an exhaustive catalogue, it nevertheless seeks to investigate the special kind of affection that film cameras seem to feel for this unique city. Hundreds of films have been shot in Florence: some have been so enamoured with its calm, glistening surface that they have not attempted to get to its core, its inner rawness, its violent past. Others have tried to engage its mystery, scratching the glossy patina and finding beauty in its troubled history. This book celebrates both approaches, because they are, in a sense, true to what the city has come to represent. A towering achievement of human ingenuity, home of unparalleled architectural treasures, once the artistic centre of the world, Florence is more than just a pilgrimage destination for artists. It is a city with a rich and complex history, whose layers must be peeled with the utmost care and attention just to discover that epidemics of Black Death, murderous coups, Nazi bombings and disastrous floods all lead to the words of a creative 9-year-old and her desire to celebrate beauty – to make beautiful art, in Florence, and about Florence. ✤

Alberto Zambenedetti, Editor

FLORENCE

City of the Imagination

Text by
ALBERTO
ZAMBENEDETTI

THE CITY THAT GAVE BIRTH to the Italian Renaissance has quite fittingly had a long-standing relationship with the visual arts, including cinema and photography. Florence's picture-perfect cityscape and breath-taking countryside have been utilized by numerous film-makers to varying results: while some integrated the landscape into their filmic discourse with truly remarkable skill, others were unable to master its complexity and flattened it to make it fit their forgettable, bi-dimensional movie postcards. Yet cameras from around the world return routinely, undeterred, to try to capture the famously ideal urban environment, its surrounding hills, and the picturesque towns that dot the Tuscan countryside. Far from the result of some utopian urban plan, Florence's beauty was forged by centuries of conflict, back-room dealings, flimsy allegiances and murderous betrayals. Its famous architectural and artistic landmarks are, more often than not, the fruit of an aggressive patronage of the arts that was born out of a desire to upstage rivals rather than to enrich the cultural landscape. To quote Orson

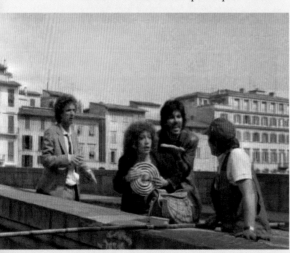

Welles as Harry Lime in *The Third Man* (Carol Reed, 1949)

You know what the fellow said – in Italy, for thirty years under the Borgias, they had warfare, terror, murder, and bloodshed, but they produced Michelangelo, Leonardo da Vinci, and the Renaissance. In Switzerland, they had brotherly love – they had 500 years of democracy and peace, and what did that produce? The cuckoo clock.

The Renaissance, widely acknowledged as the most important and influential cultural and artistic moment of the second millennium, has been at the centre of many cinematic investigations, from artist biopics to period dramas, from adaptations of literary masterpieces to spoofs and comedies. Perhaps inspired by Harry Lime's quip, Sir Carol Reed himself directed *The Agony and the Ecstasy* (1965), a biography of Michelangelo played by a tormented Charlton Heston opposite Rex Harrison as an often-irate Pope Julius II. Still the golden standard for biopics of mercurial Tuscan artists, Reed's film had many successors, including *Una vita scellerata/A Violent Life* (Giacomo Battiato, 1990), which draws from Benvenuto Cellini's own account *Vita*, written by the artist between 1558 and 1562. While Leonardo da Vinci appears as a character in hundreds of titles, he becomes the protagonist only in the 1971 miniseries *La vita di Leonardo da Vinci/The Life of Leonardo da Vinci* (RAI Radio Televisione Italiana), directed by Renato Castellani and starring the suave French actor Philippe Leroy as the eccentric Tuscan genius.

The Grand Tour brought many educated travellers to Florence; eager to experience first-hand its artistic treasures, these illustrious tourists recorded their journeys in travelogues that would become essential reads, such as William Thomas Beckford's *Dreams, Walking Thoughts and Incidents* (1783) or Johann Wolfgang von

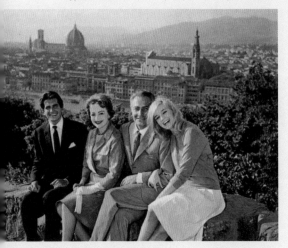

Goethe's *Italian Journey* (1816–17). The modern equivalents of these volumes are the many films that use Italy's landscape as a backdrop for journeys of self-discovery, such as *Under the Tuscan Sun* (Audrey Wells, 2003), based on the 1996 bestseller by Frances Mayes, or the Ryan Murphy-helmed blockbuster *Eat, Pray, Love* (2010), a globally inclined descendant of the Florence-centred classic *Light in the Piazza* (Guy Green, 1962), in turn based on the eponymous, bigoted 1960 novella by Elizabeth Spencer. But not all the (primarily female) descendants of Grand Tourists consume the Tuscan landscape, food and men, with nonchalant levity: Jane Campion's ambitious 1996 adaptation of Henry James's *The Portrait of a Lady* is a brooding affair that approaches themes of love, lust and obsession with the appropriate gravitas.

While Florence's art and architecture have been at the centre of many foreign productions, domestic film-makers have focused more on what it means to be from Tuscany and, specifically, to have Florentine origins. Struggling under the enormous weight of its prestigious history, humble characters move through the lesser travelled corners of the city, sometimes plagued by a sense of melancholy and

> **While Florence's art and architecture have been at the centre of many foreign productions, domestic film-makers have focused more on what it means to be from Tuscany and, specifically, to have Florentine origins.**

nostalgia, such as in the mid-century adaptations of Vasco Pratolini's eponymous novels *Cronache di poveri amanti/Chronicle of Poor Lovers* (Carlo Lizzani, 1954) and *Le ragazze di San Frediano/ The Girls of San Frediano* (Valerio Zurlini, 1955). In an Italy struggling to find its moral compass, disoriented by 21 years of Fascism and World War II, these films provided a comforting picture of a humble, hard-working, well-meaning, yet somewhat provincial country on the brink of the epochal socio-economical shift that would later be known as the economic boom. At the same time, films like *Porta un bacione a Firenze/Give Florence a Kiss for Me* (Camillo Mastrocinque, 1956) constituted a domestic alternative to the Technicolor spectacles manufactured by the rising 'Hollywood on the Tiber'.

The long tradition of humour and satirical pamphleteering in Florence, and Tuscany at large, find their cinematic equivalent in the work of the Giancattivi trio (Francesco Nuti, Alessandro Benvenuti and Athina Cenci), the globally recognizable Roberto Benigni and Leonardo Pieraccioni, among others. Pieraccioni's 1995 debut *I laureati/The Graduates*, for example, wittily tackled the issue of Italian 'mammoni' (menchildren) by investigating the lives of four thirty-something men sharing an apartment in Florence; unfortunately, the director subsequently lost his bite and retreated into the facile formulas of romantic comedies, casting himself as a lead against the tabloid bombshell of the hour. Conversely, the resilience of Benigni's quintessentially Tuscan humour – an eclectic mix of lowbrow jokes and highbrow references, sometimes delivered in song – has characterized his long and successful career up to his Oscar-winning performance in *La Vita è bella/Life is Beautiful* (1997). Co-written and directed by Benigni, the film is set in an idealized Tuscan town – a composite of Arezzo, Montevarchi, Castiglion Fiorentino, Cortona, Ronciglione, Rome and Papigno. Lastly, in their debut film *Ad ovest di Paperino/West of Paperino* (Alessandro Benvenuti, 1982), the Giancattivi comedians painted the Florentine landscape in a light much different from that of the Grand Tour films: far from the pristine urban extravaganza that perhaps existed only in the Anglo-Saxon imagination, Florence becomes a city like any other, in which the rich and the poor must uneasily co-exist, and in which beauty and dreariness often cross each other's paths. ✤

VIEWS FROM THE GRAND TOUR(IST)

Text by
ELEANOR ANDREWS

Florence and Foreign Consumption

IN THE FILM ADAPTATION of E. M. Forster's 1908 *A Room with a View* (James Ivory, 1985), a young Englishwoman, Lucy Honeychurch (Helena Bonham Carter), is taken on a carriage ride through the Tuscan countryside. During the journey she declares that she is a tourist, happy to be sent like a parcel from Venice to Florence, Florence to Rome. Tourism, certainly as far as Italy is concerned, is a vestige of the European Grand Tour, which had its origins amongst the British aristocratic classes of the seventeenth century. Filtering down through society from the nobility to the wealthy and then to the middle classes, this extended visit operated as an instructive rite of passage, with a fairly standard itinerary through France and Italy in a quest for art and culture, with consideration of the natural beauty afforded by the landscape a later addition. The principal purpose of the

Grand Tour was to present the cultural legacy of classical antiquity and the Renaissance to these travellers, as well as introduce them to fashionable European society, and give them the opportunity to acquire artefacts and antiquities. Florence was one of the key sites on the itinerary, with a visit to the Duomo and the Uffizi Gallery being considered as essential.

The Portrait of a Lady (Jane Campion, 1996) and *Room with a View* are both partially set in Florence. The films share a number of themes, since the protagonist of each is a young woman whose life will be changed forever following a trip to Italy. Both narratives address the issue of personal freedom or the lack of it as well as demonstrating the contrast in the ways of life at home and abroad. The aroused sensuality felt by the female protagonists is contrasted with the restricting mores of their times in the nineteenth and early twentieth centuries. However, in comparison with *A Room with a View* and also *Tea with Mussolini* (Franco Zeffirelli, 1999), *The Portrait of a Lady* shows little of the tourist aspect of Florence. When the monuments of the city, such as the Duomo, are displayed in Campion's work, they are seen at unsettling oblique angles suggestive of turmoil in the state of mind of the young female protagonist, Isabel Archer (Nicole Kidman). The elaborate, opulent and sometimes overwhelming interior *mise-en-scène* serves as the backdrop to the increasingly suffocating relationship between Isabel and her husband Gilbert Osmond (John Malkovich), rather than being examples of Italian design and cultural artefacts.

In *A Room with a View*, Florence and the Italian way of life is under the close scrutiny of

Above © 1985 Goldcrest Films International

Opposite © 1999 Cattleya, Cineritmo, Medusa Film

the Edwardian English upper-middle-classes. The narrative tells of the sexual awakening of the heroine, Lucy, thanks to the liberating effects of the Tuscan countryside and the Latin temperament. On the one hand, the English characters are shocked at the brutality and passion they witness, which contrasts with the genteel, but frequently artificial, nature of the English way of life; on the other, they are seduced by the loveliness of both the natural (Tuscany) and man-made (Florence) environments they have come to observe. Novelist Eleanor Lavish (Judi Dench) treats the visit to the city as a great adventure. She despises those visitors who slavishly follow their Baedeker travel guides, and aims for a more spontaneous experience. As though dealing with wildlife specimens, she finds 'the Italians unspoiled in all their simplicity and charm'. Lucy, in contrast, describes the Italians as being 'so kind, so loveable' but 'at the same time so violent'. In the Piazza della Signoria Lucy witnesses a fatal stabbing at close hand. The photos that she had purchased only moments before, as a souvenir of the beauty of the square, are spoiled by the blood of the murder victim. On the journey into the countryside surrounding the city, Lucy watches the amorous behaviour of the young Italian carriage driver and his sweetheart through the binoculars with which she is supposed to be surveying the landscape. The guileless actions of the Italians are condemned by the Reverend Mr Eager, and yet, later on, it is the intuitive understanding of this driver which engineers the meeting and subsequent kiss between Lucy and George Emerson (Julian Sands). After a period of confusion and indecision back at home, Lucy finally rejects her stiff, affected English fiancé, Cecil Vyse (Daniel Day-Lewis) in favour of George, the man she fell in love with in Italy. The final scene reveals a happy ending, following the marriage of Lucy and George. The couple sit by an open window, with a view of Florence in the background. Lucy's soft, casual clothing and her tumbled hair show the transfigured, passionate protagonist who might appear as the heroine in the latest novel by Eleanor Lavish.

A more nuanced, and sometimes jaded, perspective of the Italians is given by the resident English ex-patriots in 1930s Florence in *Tea with Mussolini*. The film opens in the English Cemetery by the tomb of the English poet, Elizabeth Barrett Browning, who with her husband, Robert Browning, made Italy her home for fifteen years in the nineteenth century. The choice of this figure and this particular location serves to reinforce the notion of the strong links forged between the two countries at that time, and highlights the shocking nature of the events in World War II which damaged these bonds. There is a similar contrast between nations made in this film, but the transformative power comes not from the Italians or their city, but from the spirit of the *Scorpioni* (scorpions), a small group of elderly English ladies who lived in Florence in the 1930s and 1940s. Once again playing the role of the artistic Englishwoman abroad, Judi Dench as Arabella says the Italians are 'not like us cold English', and, referring to the cultural heritage of the country, she declares, 'I've warmed both hands before the fires of Michelangelo and Botticelli.'

The choice of Florence as a setting for these films offers the spectator a visual and narrative comparison between, on the one hand England and America, and on the other Italy, based on an Anglo-Saxon notion of the Italian stereotype, which suggests that Italians are passionate and pleasure-loving, artistic and impulsive, musical and imaginative, religious and revengeful. ✤

In *A Room with a View*, Florence and the Italian way of life is under the close scrutiny of the Edwardian English upper-middle-classes.

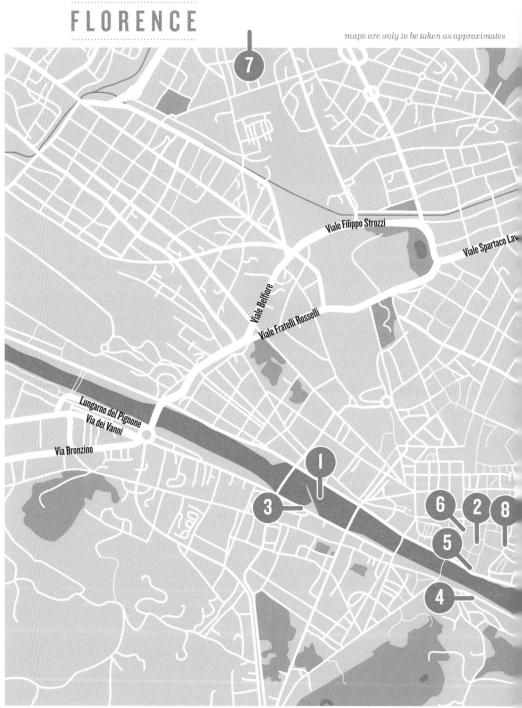

LOCATIONS MAP

FLORENCE

maps are only to be taken as approximates

FLORENCE LOCATIONS
SCENES 1-8

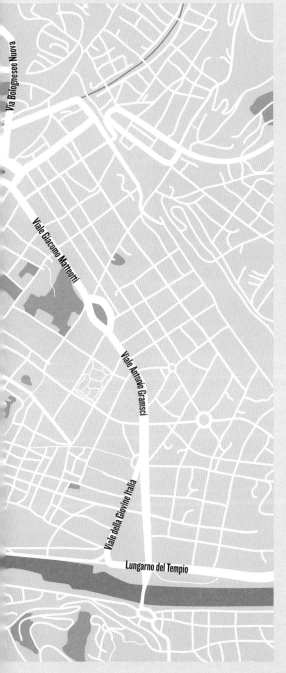

ROMOLA (1924)

The Arno River

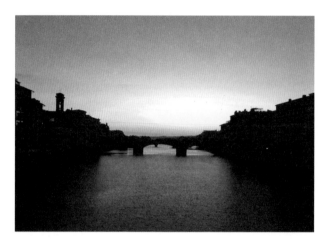

A FLORENCE BESET BY religious and political turmoil furnishes the backdrop for Henry King's adaptation of the George Eliot novel (1862–63). Set in the year 1492, King unfurls a story of adventure and romance into streets populated by such historical figures as the firebrand preacher, Savonarola (Herbert Grimwood), and the opulent Medici family. The film begins with the main character, Tito Malemma (William Powell), and his encounter with the esteemed scholar Bardo Bardi (Bonaventura Ibáñez), who mistakes Tito for a respected man of letters. Tito seizes on this error to enter high society through a propitious marriage to Romola (Lillian Gish), Bardi's daughter, despite already being married to and fathering a child with the milkmaid Tessa (Dorothy Gish). When Romola realizes she has been duped and Tito attempts to usurp the city's throne, the Florentines turn against him, forcing him from a window into the river below. We first see shots of the river early in the film when Tito courts Tessa. There, King embeds the two star-crossed lovers in the idyll of the city's central waterway. When he plunges into the river to escape, however, the comedy and romance that dominate much of the film fade into tragedy. Tito allows Tessa to sink to the river's bottom then is drowned by the father he betrayed. The ominous swirl of the Arno's deadly current makes a perfect complement to the tempestuous love-triangle portrayed in the film, as well as the turbulence of fifteenth-century Florence.
⊷Brendan Hennessey

Photo © Alberto Zambenedetti

Directed by Henry King
Scene description: *Tito courting Tessa by the Arno River; Bardo drowns Tito*
Timecode for scene: *0:21:35 – 0:23:20 (Figures 1 through 3); 1:38:02-1:41:14 (Figures 3 though 6)*

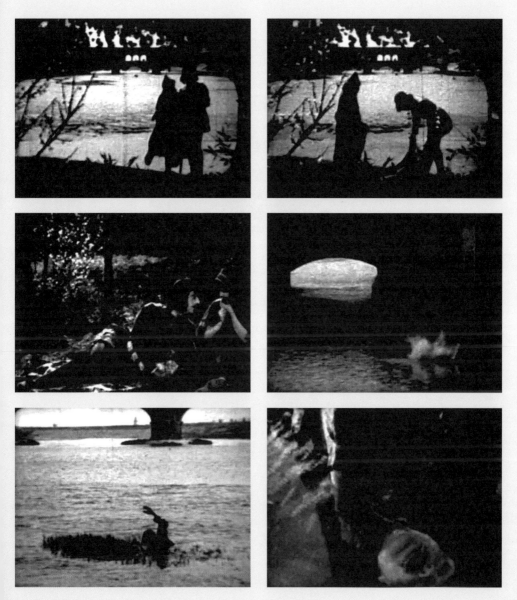

CONDOTTIERI (1937)

LOCATION *Loggia dei Lanzi, Piazza della Signoria*

CONDOTTIERI IS BASED on the life of Giovanni de' Medici (1498–1526), better known as Giovanni dalle Bande Nere. Father of Cosimo il Primo, the first Duke of Florence, Giovanni was a mercenary soldier (*condottiere*) that fought first for Pope Leo X and then for Charles V. Director Luis Trenker depicts this historical figure in a way that is consistent with Fascist propaganda. In fact, in *Condottieri* Giovanni is a charismatic leader, who aims to expel foreigners from Italy and to create a unified state; therefore, the director establishes a clear parallel between Giovanni and Benito Mussolini. In the course of the film the protagonist gets into a fight with the Florentine Signoria, whose members are interested in maintaining their power and in opposing Giovanni's nationalist goals. Trenker depicts this clash through the representation of Florence's monuments and urban space. Giovanni appears as the leader of the common people, and his purity and authenticity differ from the lavish court-life of the elitist Florentine rulers. Giovanni's manners and his rough physique strongly contrast with the elegant Renaissance and Mannerist sculptures set in Piazza della Signoria. Michelangelo's *David* (1501–04) and Baccio Bandinelli's *Hercules ad Cacus* (1534), located in front of Palazzo Vecchio, and Benvenuto Cellini's *Perseus with the Head of Medusa* (1545), located under the Loggia dei Lanzi, the arched structure built between 1376 and 1382 by Benci di Cione and Simone di Francesco Talenti, are in Trenker's film the negative expression of Florence's powerful and threatening government.
❖Roberto Vezzani

Photo © Alberto Zambenedetti

Directed by Luis Trenker
Scene description: [4 scenes] Signoria's members discuss about Giovanni; the first
confrontation between Giovanni and the Signoria; Giovanni escapes from the prison
by night; Giovanni's battle for the conquest of Florence
Timecodes for scenes: 0:26:31 – 0:27:36 (Figures 1 and 2); 0:29:09 – 0:31:07 (Figure 3);
0:46:39 – 0:48:46 (Figure 4); 1:05:05 – 1:06:11 (Figures 5 and 6)

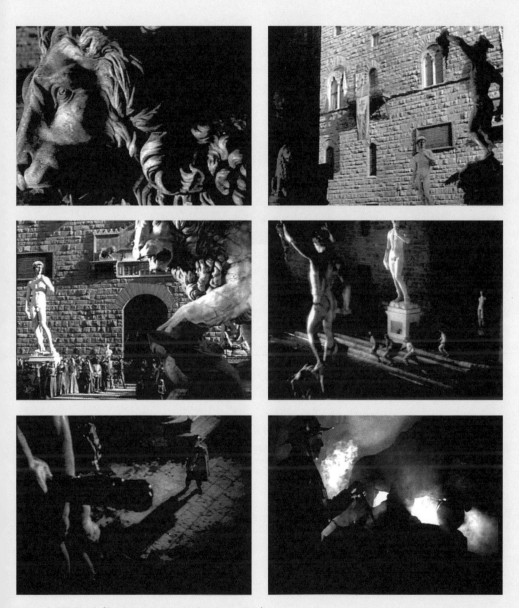

Images © 1937 E.N.I.C. (Ente Nazionale Industrie Cinematografiche)

TRAGIC NIGHT/TRAGICA NOTTE (1942)

Lungarno Soderini, east of the Ponte Vecchio

SET LARGELY IN A SMALL TOWN in the hilly Tuscan countryside, Mario Soldati's *Tragic Night* contains a lengthy flashback that informs the viewer of the moral dilemma faced by the film's female protagonist, Armida, played by the stunning Doris Duranti. Count Paolo Martorelli (Adriano Rimoldi) returns to his native land after a two-year stint in America, where he had travelled to recover from a broken heart. He learns that the woman he was courting, and who rejected his affections, married his childhood friend Nanni (Andrea Checchi). A modern-day Iago, gamekeeper Stefano (Carlo Ninchi) seizes the opportunity to settle the score with Nanni, with whom he has a standing mutual antipathy, by planting the seed of jealousy in Nanni's heart, and persuading him to kill the count during a hunting trip. When Paolo first visits Nanni at this emporium he triggers Armida's memory of their encounter in Florence, which happened two years prior. After almost running her over with his car, the Count asks the woman to meet him at Lungarno Soderini, the southern stretch of river-bank road that connects the Santa Rosa Tabernacle to the Carraia Bridge. He shows up at the appointments in his fancy automobile, only to sit in it and smoke countless cigarettes while Armida watches him from afar. Temped by Paolo's impeccable manners and wealth, Armida almost betrays her Nanni, but in the end she runs off without offering an explanation of her behaviour to the love-struck aristocrat.
⟿ *Alberto Zambenedetti*

Photo © Alberto Zambenedetti

Directed by Mario Soldati
Scene description: Adriano Rimoldi waits for Doris Duranti, while she hides and watches him
Timecode for scene: 0:26:01 – 0:28:00

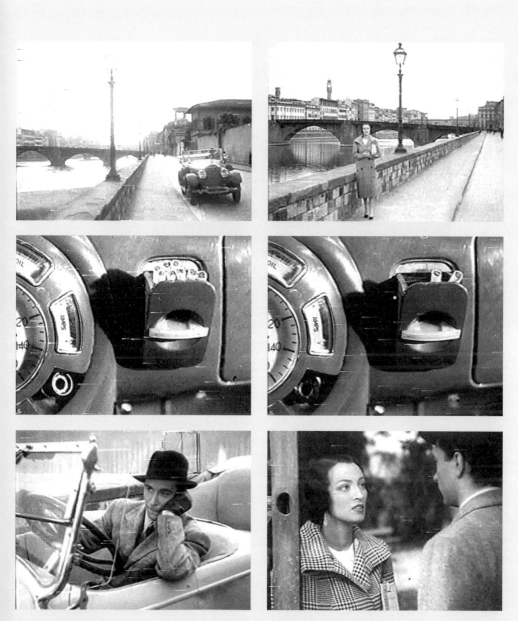

SORELLE MATERASSI (1944)

Lungarno Torrigiani, west of the Ponte Vecchio

SORELLE MATERASSI tells of three spinster sisters and the disrupting entry of a handsome nephew, Remo (Massimo Serato), into their home. While their domestic space is oppressively secure, Florence, the grand city down the road, holds innumerable attractions. Seventeen minutes into the film viewers see just how liberating Florence can be, in a brief tracking shot along the Arno River. The related sequence begins with a shot of Remo running out of his aunts' home one bright morning to meet a friend, who waits eagerly with bicycle in hand. As the men jump on the bike the shot fades into a new image of the two riding along the Lungarno Torrigiani. Remo pedals while his friend sits side-saddle across the top bar. They are filmed centre-frame, moving swiftly forward as the camera tracks back. Viewers note the Ponte Vecchio in the blurred background to the men's left, a few well-dressed walkers pausing to look over the river's edge, and a series of long shadows across the sun-drenched road. The men, heads tucked close, speak eagerly about the bargain awaiting them. The Florentine scene behind them is sedate in comparison to their frenetic joy, yet the openness of the space and swift movement that it allows stand in sharp contrast to the domestic interiors dominating the film. Just like that, the shot fades again, moving to an image of the men staring at a gleaming motorcycle for sale, the means to even greater adventure.
➥**Monica Seger**

Photo © Alberto Zambenedetti

Directed by Ferdinando Maria Poggioli
Scene description: Remo and a friend bike along the Arno River
on their way to look at a motorcycle for sale
Timecode for scene: 0:17:01 – 0:17:15

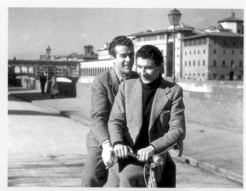
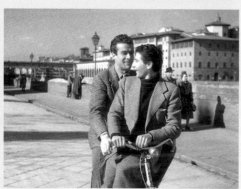

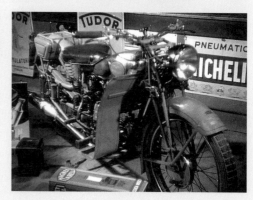

PAISAN/PAISÀ (1946)

LOCATION *Vasari Corridor*

ALTHOUGH THEY ARE NOT DIRECTLY inscribed in the title, the second instalment in Roberto Rossellini's War Trilogy has a very strong relationship with its locations. Similarly to its counterparts *Roma città aperta/Rome Open City* (Roberto Rossellini, 1945) and *Germania, anno zero/Germany Year Zero* (Roberto Rossellini, 1948), *Paisan* investigates human relations on the background of a war-torn landscape. Out of the six episodes that constitute the film, three are set in urban areas, one of which is Florence. *Paisan* revisits one of the city's darkest hours: the German occupation in the summer of 1944, which transformed the cradle of the Renaissance into a battlefield, the Arno River separating the opposing armies. In this episode, American nurse Harriet (Harriet) and Massimo (Renzo Avanzo) cross the river into enemy territory to reconnect with loved ones. The only bridge left standing by the Germans was the Ponte Vecchio, which Hitler himself deemed too important to destroy. Of course, atop the bridge sits the Vasari Corridor, which connects Palazzo Pitti all the way across the Arno, through the Uffizi Gallery and into Palazzo Vecchio. The Führer knew the structure very well, having walked through the corridor during his 1938 official visit to Italy. Commissioned to Giorgio Vasari by Gran Duke Cosimo I De' Medici, and built in only five months in 1565, the passageway allowed the duke to move swiftly and safely between his residence and the government building, avoiding the crowds. For the Florence episode Rossellini took full advantage of this unique architectural feature, including mentioning its temporary partial interruption. ➔ ***Alberto Zambenedetti***

Photo © Alberto Zambenedetti

Directed by Roberto Rossellini
Scene description: Florence Episode: Harriet and Massimo
cross the Arno River using the Vasari Corridor
Timecode for scene: 1:09:28 – 1:12:28

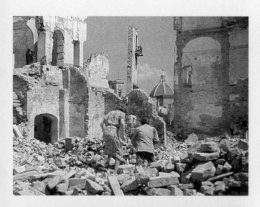 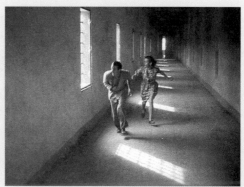

 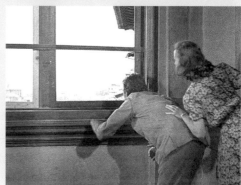

 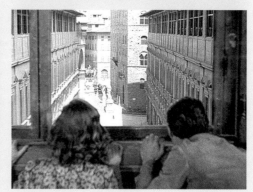

SEPTEMBER AFFAIR (1950)

Ristorante Orcagna, Piazza della Signoria

SEPTEMBER AFFAIR offers an early vision of the tourist film, a trend that was to thrive throughout the 1950s with films like *Roman Holiday* (William Wyler, 1953), and *Summertime* (David Lean, 1955). It begins in Rome, and makes panoramic stops in Naples, Pompeii and Capri before settling in the adopted home of its protagonists, Florence. Manina Stuart (Joan Fontaine) and David Lawrence (Joseph Cotten) first cross paths at an air-travel office on Rome's Piazza della Repubblica; both plan to return to the United States, yet when a missed plane crashes – and they are presumed dead – they seize the opportunity to escape their old lives and nurture a romance sparked in Naples. Manina, we learn, first came to Florence as a young music student, and fondly recalls a celebratory meal at the Ristorante Orcagna. She offers to take David on a 'Cook's Tour' of the city, and they wind up on the Piazza della Signoria, gazing on Michelangelo's *David*. An aerial shot follows the lovers into the restaurant, and inside, plates of spaghetti bolognese and bottles of Chianti give way to an impromptu musical performance. Manina plays the song they listened to on a gramophone in Naples ('when we really discovered each other') and that inspires the film's title: Kurt Weill's *'September Song'* (1938). Perhaps most intriguingly of all, the restaurant is papered in travel posters that suggest both the itinerary and the rootlessness of their European love affair. •*Joseph Perna*

Directed by William Dieterle
Scene description: Manina Stuart takes David Lawrence to her favourite restaurant in Florence
Timecode for scene: 0:48:28 – 0:55:10

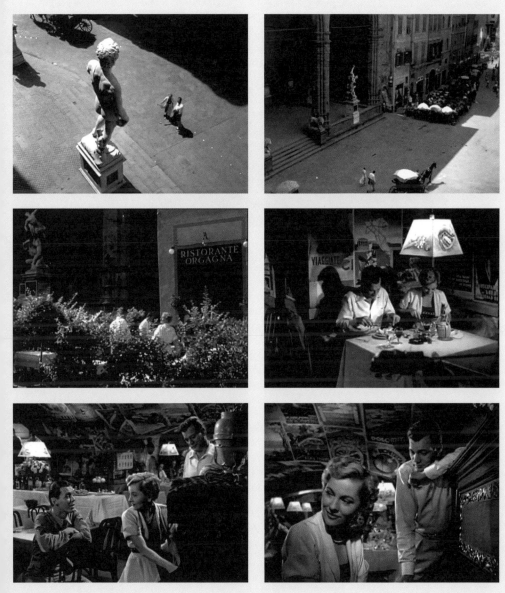

THE WORLD CONDEMNS THEM/
IL MONDO LE CONDANNA (1953)

LOCATION *Via di Rifredi*

THE TALE OF THE PROSTITUTE compelled by law to return to her family home was common in 1950s film melodrama, a narrative trope that drew on the arcane state regulation of prostitution that lasted until 1958 in Italy, here represented by the 'foglio di via' (expulsion notice). *The World Condemns Them* is unusual insomuch as its protagonist Renata (Alida Valli) does not return to a rural environment, where her urban, dyed-blonde sophistication and fur coat are juxtaposed with peasant ignorance, but to the working-class district of Rifredi, thrown into grey, smoky relief, not only by the protagonist's polish, by also by preceding flashbacks of the neon lights of Paris. After brief shots of her return to her rail-side family home, and its modest, respectable interior, Renata's first night in Rifredi is marked first and foremost aurally, as she is kept awake all night by the constant passing of trains and the wail of factory sirens. The next morning, as she accompanies her younger sister to school, she encounters the admiring gazes of local working men, and envious gazes of women, as well as the curiosity of the prostitute's classic counterpart in 1950s Italian melodrama, the nun. Here we see Rifredi's bleak industrial qualities used nonetheless to counter that common critique of the melodrama as a closed, anonymous world of Manichaean values. This is most definitely Italy, albeit within the moral framework of melodrama, but it is a recognizable depiction of working-class poverty that contextualizes the protagonist's choices sympathetically. **⇢Danielle Hipkins**

Photo © Elizabeth Williams

Directed by Gianni Franciolini
Scene description: Renata returns to her home in Rifredi after life as a prostitute in France
Timecodes for scenes: 0:08:43 – 0:12:20 and 0:13:40 – 0:17:35

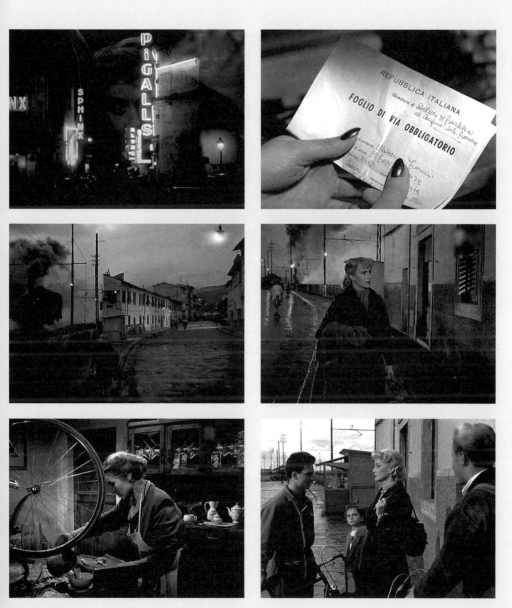

CHRONICLE OF POOR LOVERS/ CRONACHE DI POVERI AMANTI (1954)

LOCATION *Via del Corno, a Florentine residential street*

IN HIS NOVEL *Cronache di poveri amanti* (1947), Vasco Pratolini aimed to capture the timeless essence of Florence within a specific period of time: 1925–26, the years in which Fascism consolidated its power in Italy. When Carlo Lizzani adapted Pratolini's novel for the screen, he achieved the same fusion of the timeless and the time-bound by juxtaposing shots of Florence's medieval and Renaissance landmarks with those of Florence as it appeared under Fascism. The film is set in Via del Corno, a poor neighbourhood located between Piazza della Signoria and Piazza Santa Croce that, despite its proximity to many of Florence's major monuments, was isolated like an island in the middle of the city. We sense both the street's centrality and its isolation in the scene in which Mario (Gabriele Tinti) first arrives in Via del Corno, emerging onto the balcony of his new apartment and looking out over the Palazzo Vecchio and the Basilica di Santa Maria del Fiore. The film's geography, we recognize, is at once anchored in the Florentine cityscape and divorced from that cityscape's touristic connotations. The distant chimes of the Palazzo Vecchio only serve to emphasize how the poor residents of Via del Corno are cut off from the rest of the city. **◦►Charles Leavitt**

Directed by Carlo Lizzani
Scene description: Mario arrives in Via del Corno
Timecode for scene: 0:04:50 – 0:07:13

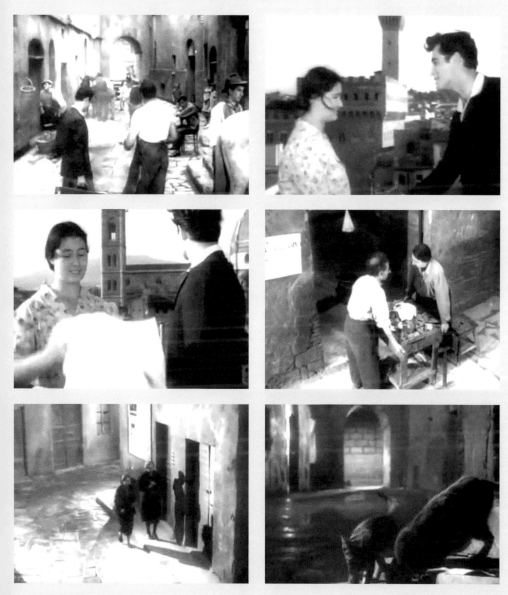

FLORENTINE ARTISTS ON FILM

Michelangelo and Leonardo da Vinci

Text by
NATHANIEL
J. DONAHUE

THE CINEMATIC VISTAS and monumental grandeur of the Florentine cityscape can evoke the sensation of walking in a Renaissance movie set. This is no accident, for the urban fabric of the city's core is the result of centuries of careful civic planning from the late gothic period through the building booms of the Renaissance. Piazzas, church facades, monasteries, palaces and streets were all designed to form interlocking scenographic public spaces that framed the urban experience as theatre, an environment that prominent architectural historian Marvin Trachtenberg has called 'the dominion of the eye.' The list of strategic viewpoints created by planners is long, whether it be the view of the Palazzo Vecchio from the north end of the Piazza della Signoria, the planned bend in the Via Cavour that showcases the expansive Palazzo Medici, or the

numerous vistas of Brunelleschi's dome that were planned with specific angles of vision in mind, and for which various entrances to the piazza were created. In each case Florentine urban planners have always combined architecture and streets in a manner that emphasizes the Florentine identity as monumental and marvellous, the result of a glorious heritage of progress, aesthetic innovation and cultural vanguardism.

The opening sequence of director Carol Reed's 1965 *The Agony and the Ecstasy*, starring Charlton Heston as a cantankerous Michelangelo Buonarroti, is essentially a twelve-minute slide lecture featuring still shots of the aforementioned vistas and monuments that shape the visual character of Florence. Postcard views of the Duomo, Orsanmichele, Ponte Vecchio and Santa Maria Novella serve as the backdrop for Michelangelo's singular genius, and are followed by a sequence of shots devoted to his sculptures. The omniscient voice of the narrator tells us they are 'roughly hewn like the first vague light of dawn'. Specifically, the *David* is presented as a symbiotic expression of the union between the iconic city and the artist, structuring Michelangelo's mythic biography according to paradigms traditionally associated with Florentine civic identity: experimentation, innovation, idealism and a rejection of traditional social and aesthetic boundaries. The powerful connection between man and city had first been made in 1549 by the celebrated historian Giorgio Vasari, a biographer who celebrated Michelangelo as the semi-divine pinnacle of Florentine achievement: 'the perfection Florence justly achieved with all her talents finally

reached its culmination in one of her own citizens' (Vasari, p. 415). A colossal personality, conflicted but committed to perfection, grace and glory, Heston's Michelangelo personifies the mythic spirit of Renaissance Florence – a willingness to be self-critical, exacting and to make any sacrifice in the pursuit of the ideal.

Michelangelo's biography in the art historical literature is fraught with intrigue, from his frequent inability to finish commissions, difficult relationships with patrons and likely sexual relationships with male partners. Heston's portrayal of Michelangelo is famously tortured, and emphasizes the emotional burdens often associated with creative genius in the modern imagination: a unique vision that is celebrated but nevertheless makes one an outsider and a target of scrutiny. The film's narrative action is structured around the opposition of two titanic personalities, Michelangelo and his demanding patron Pope Julius II. The Herculean effort required to complete the commission of the Sistine Chapel is presented as the crucible in which the artist must overcome adversity, doubt and fear of inadequacy during the struggle to achieve a masterpiece. Michelangelo's successful completion of the ceiling is thus framed as the classic underdog story – ultimately a manifestation of the Oedipal struggle

The lives of the artists become a metaphor for Florentine civic identity: modern, monumental, innovative and bold.

itself. The film thus pits creative genius and progressive vision, emphasized as a characteristic of Florence, against the conservative and dogmatic qualities embodied by Julius and papal Rome – a reimagining of the David and Goliath story that ends with an exhausted Michelangelo triumphant yet spent.

Leonardo de Vinci is likewise represented as an anti-hero whose genius has a dark underbelly in David S. Goyer's television series *Da Vinci's Demons,* which aired on the Starz Network in 2013. Soap operatic and titillating, the series lacks any of the stoic seriousness and lofty pretensions of *The Agony and the Ecstasy*, yet like Heston's Michelangelo, Leonardo's character is the manifestation of his city's mythic qualities and genius. Goyer's reimagining of Leonardo's biography portrays the title character played by Tom Riley as a revolutionary, a precocious young rogue with an extreme talent for painting, mathematics and engineering, and who also is a bisexual opium addict. Florence is heralded as a city where 'chaos and culture are all celebrated within these walls', and '[the city] demands only one thing of her people: that they be awake'. This quality of 'being awake' reveals itself in the young Leonardo's superhuman powers of observation, expressed through animated sequences of notebook drawings. Like Michelangelo, who is given divine capabilities by Vasari in his sixteenth-century *Lives of the Artists,* the modern imagination pictures the quintessential Renaissance man as beyond human, a genius that expresses itself through physical and mental gifts as well as a degree of anxiety and neurosis.

The template for the biography of the 'great artist' is perhaps little changed from Vasari's time until our own. The Renaissance genius, represented by Michelangelo and Leonardo, is presented as a paradigm of struggle and self-doubt, an obsessive quest for perfection that results in sacrifice but also superhuman achievement. The lives of the artists become a metaphor for Florentine civic identity: modern, monumental, innovative and bold. In the cases of *The Agony and the Ecstasy* and *Da Vinci's Demons* the possession of genius, and the modern spirit of self-criticality, comes at a price for Michelangelo and Leonardo. Towering above other mortals, the divine origin of their gifts sets them apart from other men, making their talents praised and sought after but their lives solitary and misunderstood. ✦

N

LOCATIONS MAP

FLORENCE

Viale Filippo Strozzi

Viale Spartaco La*

Viale Belfiore

Viale Fratelli Rosselli

13

Lungarno del Pignone

Via dei Vanni

Via Bronzino

10

11

12

9

FLORENCE LOCATIONS
SCENES 9-15

9.
THE GIRLS OF SAN FREDIANO/
LE RAGAZZE DI SAN FREDIANO (1955)
Via dei Preti, 6
page 32

10.
GIVE FLORENCE A KISS FOR ME/
PORTA UN BACIONE A FIRENZE (1956)
Carriage ride past the Loggia del Porcellino
page 34

11.
IT HAPPENED IN ROME/
SOUVENIR D'ITALIE (1957)
Exterior of Palazzo Vecchio
page 36

12.
THE LOVEMAKERS/LA VIACCIA (1961)
Piazza del Carmine
page 38

13.
LIGHT IN THE PIAZZA (1962)
Santa Maria Novella railway station
page 40

14.
LOVE ON A PILLOW/
LE REPOS DU GUERRIER (1962)
Piazza San Pier Maggiore
page 42

15.
FAMILY DIARY/
CRONACA FAMILIARE (1962)
Via delle Casine, a residential street
near the centre of Florence
page 44

THE GIRLS OF SAN FREDIANO/
LE RAGAZZE DI SAN FREDIANO (1955)

Via dei Preti, 6

THE GIRLS OF SAN FREDIANO begins not with its eponymous women but with their tormentor, a local Don Giovanni, cruising along the Arno on a borrowed motorbike. A dedicatory title informs us that handsome young Florentines were often called 'Bob' after Hollywood actor Robert Taylor, and that they frequently suffered as a result, 'the innocent victims of their own fine features'. Loosely adapted from Vasco Pratolini's 1949 novel of the same title, the film follows the misadventures of one such Bob, and hews to a pocket of Florence far more precarious than one finds in Hollywood films. As Bob turns onto the Via dei Preti, we hear that this is 'the very heart of the San Frediano District', and then see what that entails: densely populated apartment houses with mechanic's shops on the ground floor, gossip and rivalry among women of varying ages, and even chickens battling an aggressive dog. Zurlini's camera pivots between Bob (distractedly lending a screwdriver to a lovelorn admirer) and the older women in his building across the street. His mother is one of them, and as she lowers a basket containing Bob's lunch, a neighbour's chickens spill into the street, prompting shouts of recrimination from three different windows, all thrown open and then angrily shut. With its porousness of public and private life, the scene efficiently sets the tone for a comedy of yearning in which Bob and his admirers alike press against the limits of their working-class lives.
➼ *Joseph Perna*

Photo © Alberto Zambenedetti

Directed by Valerio Zurlini
Scene description: Bob returns home to his mother, his admirers and a clutch of escaping chickens
Timecode for scene: 0:02:55 – 0:05:34

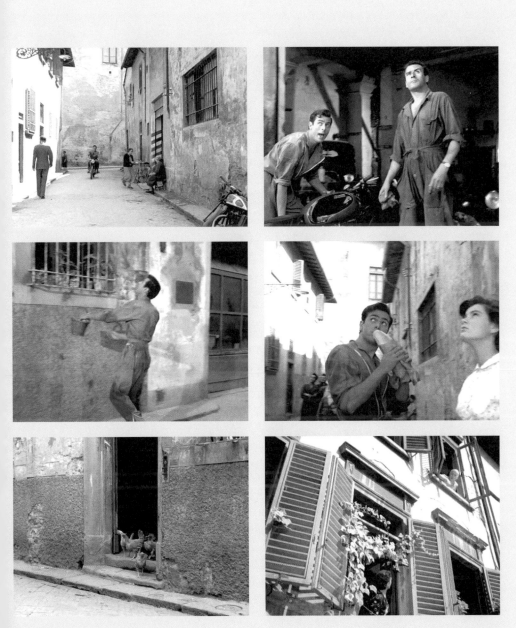

GIVE FLORENCE A KISS FOR ME/ PORTA UN BACIONE A FIRENZE (1956)

Carriage ride past the Loggia del Porcellino

DIRECTED BY former architecture student-turned-set designer Camillo Mastrocinque, *Give Florence a Kiss for Me* engages familiar locations throughout the centre of historic Florence to portray the place-based identity of Italian expatriate Simonetta (Milly Vitale). Having immigrated to the United States as a child, Simonetta longs to return to her native Florence. Named after the title song by Odoardo Spadaro (1938), who enjoys a brief cameo as an Italian emigrant, *Give Florence a Kiss for Me* depicts Simonetta's repatriation and courtship with sculptor Alberto (Alberto Farnese). Viewers first meet Simonetta in New York City where an unspecified condition compromises her eyesight. A wide-angle shot of Midtown Manhattan centred on the Empire State Building dissolves to a tilt-down on a building labelled 'Clinic of Health' where Simonetta and her father, Mr Dalmonte (Nerio Bernardi), consult an ophthalmologist who prescribes Simonetta corrective lenses. Her vision restored, Simonetta sets her sights on travelling to Italy where analogous framing during the opening credits establishes her arrival in Florence. Alongside her Italian host, Count Giulio Pineschi (Nino Besozzi), Simonetta enjoys a carriage ride through Florence that connects her to well-known attractions including the Loggia del Mercato Nuovo, popularly called the Loggia del 'Porcellino', or 'piglet', after its bronze boar fountain replica (the original Mannerist work by Pietro Tacca is located across the Arno in the Museo Bardini). Simonetta's travels through iconic Florence emphasize her environmentally-dependent wellbeing. Simonetta's visual impairment was remedied by her remediation in Florence, but she ultimately succumbs to blindness after venturing to seek Alberto beyond the city limits. **↝Sara Troyani**

Photo © Alberto Zambenedetti

Directed by Camillo Mastrocinque
Scene description: Italian expatriate Simonetta appears cured
of a visual impairment while sightseeing in her native Florence
Timecode for scene: 0:04:21 – 0:06:45

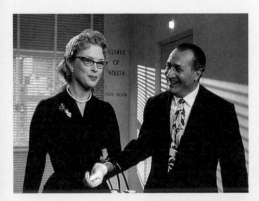 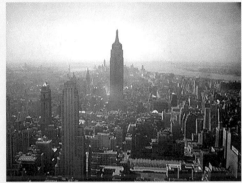

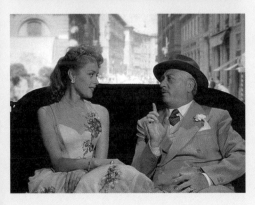

IT HAPPENED IN ROME/SOUVENIR D'ITALIE (1957)

LOCATION *Exterior of Palazzo Vecchio*

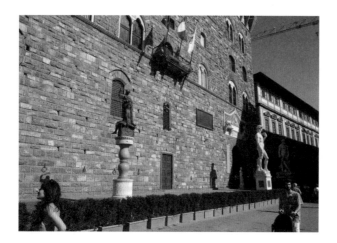

IN THIS ENTERTAINING COMEDY, a wealthy British tourist named Margaret (June Laverick) inadvertently travels through Italy with Josette (Isabelle Corey) and Hilde (Ingeborg Schöner), two university students, after a mishap with her car forces her to hitchhike across the peninsula. During their stay in Florence, Josette encounters a young Italian man named Sergio Battistini, played by renowned comic actor Alberto Sordi, and his wealthy mistress Cinzia (Isabel Jeans) while passing by the Palazzo Vecchio. Cinzia poses in front of the facade of the building next to Benvenuto Cellini's bronze statue *Perseus with the Head of Medusa* (1545), near the replica of Michelangelo's *David* (1501–04), while Sergio reluctantly takes pictures. The camera assumes the point of view of Sergio's lens and the canted frame permits a full view of the Cellini piece. The scene at once fulfils the expectations for a travel film by allowing the spectator to take in one of Florence's most popular tourist destinations, the historic town hall in the Piazza della Signoria, but the statue and the building also comically reflect Sergio's opinion of Cinzia. The Palazzo Vecchio (literally 'old building') comments on the considerable age difference between the two, and the juxtaposition of the statue and Cinzia hints at Sergio's distaste for his partner by likening her to the Medusa. The unscrupulous Sergio ogles Josette when she first appears and is quick to abandon Cinzia to pursue the younger and more alluring French student.
⬩Christopher White

Directed by Antonio Pietrangeli
Scene description: Josette meets Sergio Battistini and Cinzia
Timecode for scene: 0:37:57 – 0:40:04

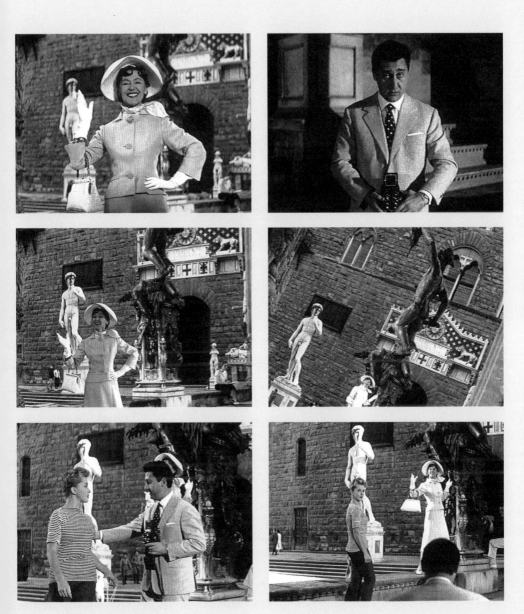

Images © 1957 Athena Cinematografica

THE LOVEMAKERS/LA VIACCIA (1961)

LOCATION *Piazza del Carmine*

MAURO BOLOGNINI'S *La Viaccia*, an adaptation of Mario Pratesi's 1889 novel *L'Eredità*, tells of familial fights over the inheritance of a stretch of farmland in the hills above Florence in 1885. In an effort to ingratiate himself and assure his eventual entitlement to the property, Stefano (Pietro Germi) sends his son Amerigo ('Ghigo', played by Jean-Paul Belmondo) to work for his brother Ferdinando, the temporary heir of 'La Viaccia', in his shop in the city. On an errand out that takes him through Piazza del Carmine, Ghigo glimpses and immediately falls for Bianca (Claudia Cardinale), a local sex worker whose brothel is on nearby Via del Presto di San Martino. Piazza del Carmine is a fourteenth-century square near Palazzo Pitti in Oltrarno, created originally to support the audiences of the Carmelite Order's sermons alongside the Church of Santa Maria del Carmine. Just as we saw earlier on in the fields of the farm, Ghigo thrives in the freedom of this open space, happy to escape the oppressions of family and work; though the pathetic fallacy of the heavy downpour is perhaps an omen of the troubles to come. The specificity of the piazza is doubtless ironic: the Carmelites stand for charism through community service, the kind of service which the older generation promotes, and which Ghigo should be doing at his uncle's shop. But the string of events that follow Ghigo's first meeting with Bianca will interrupt this, changing indefinitely Stefano's plans for La Viaccia.
⤳ Dom Holdaway

Photo © Alberto Zambenedetti

Directed by Mauro Bolognini
Scene description: Ghigo catches sight of Bianca
Timecode for scene: 0:16:40 – 0:18:21

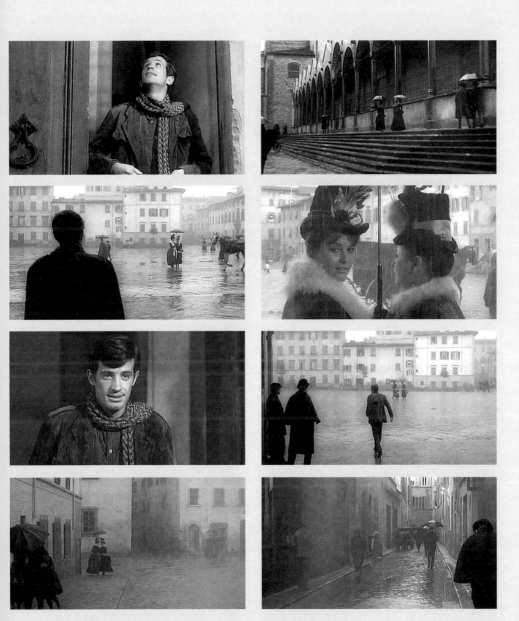

Images © 1961 Arco Film, Galatea Film, Société Générale de Cinématographie (S.G.C.), Titanus

LIGHT IN THE PIAZZA (1962)

Santa Maria Novella railway station

UNLIKE HENRY JAMES'S 1878 *Daisy Miller*, *Light in the Piazza* ends happily, as does its source material, the eponymous Elizabeth Spencer novella (1960). Meg Johnson (Olivia De Havilland) and her daughter Clara (Yvette Mimieux) have been taking in Florence. A brain injury has stranded Clara permanently in childhood; most of Florence is lost on her, save cannelloni (NB: an entirely un-Florentine dish) and Fabrizio (George Hamilton), her clowning, enthusiastic suitor, whose Italian innocence (apparently) makes her disability completely invisible to him. Consequently, Meg plots her and Clara's escape in order to avoid unpleasant revelations, but the obdurately affectionate Fabrizio finds his way to the Santa Maria Novella railway station just in time. A film in which people are not what they seem, *Light in the Piazza*'s insistence on Florence itself as real location grounds the improbable, romantic elements of the plot in a manner similar to George Eliot's scrupulous observation of the city's documentary details in her intensely melodramatic *Romola* (1862–63). Here the station's materiality asserts an effect of the real in this classic staging of the melodramatic nearly-missed encounter. The station itself is a product of Fascism; it was designed in 1932 by the Gruppo Toscano (led by Giovanni Michelucci), given Mussolini's official seal of approval and completed in 1934. The building mediates (or papers over) tensions between the harder-edged modernist and more classicizing tendencies in Fascist architectural culture and was also celebrated for its harmonious insertion into the city's historic centre. Itself a marriage of old and new, and a document of a repressed (if still very recent) past, the station resonates with the film's interest in asynchronicity and the unknowable relation between innocence and experience. **⬥John David Rhodes**

Photo © Alberto Zambenedetti

Directed by Guy Green
Scene description: Meg and Clara Johnson depart Florence for Rome;
Fabrizio arrives almost too late to bid them farewell
Timecode for scene: 0:52:37 – 0:55:41

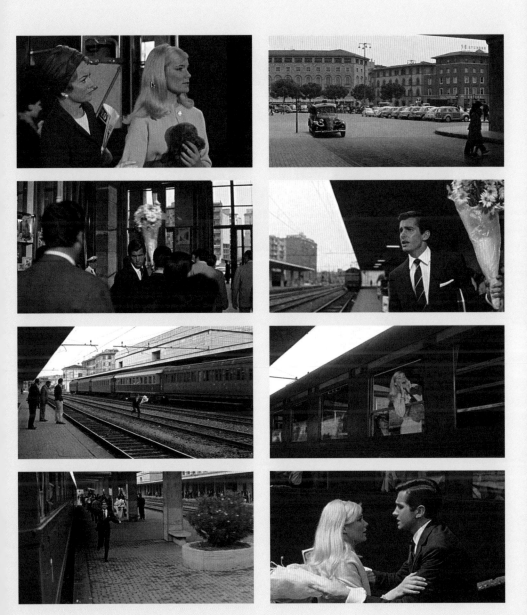

LOVE ON A PILLOW/LE REPOS DU GUERRIER (1962)

Piazza San Pier Maggiore

GENEVIÈVE (BRIGITTE BARDOT) is a bourgeoise Parisian, whose life is suddenly interrupted by a new lover, Renaud (Robert Hossein). She struggles to adapt to his violent rejection of middle-class family life, leading to repeated fights and ultimately a breaking point which happens in Florence, under the arches of Piazza San Pier Maggiore. As she watches from the car, Renaud drunkenly stumbles over to a small group of sex workers, offering one of them 10,000 lire. Silently enraged, Geneviève interrupts and offers herself as a prostitute instead, for him to laugh her off, saying 'you will always be a charming petit-bourgeoise'. This is the final straw for the woman, who takes to the car and reverses out of the piazza, along Via Matteo Palmieri. Vadim's film works hard to uncover and animate the superficiality of bourgeois relationships, suggesting open sexuality, polygamy and anarchy as alternatives. And this Florentine square, unlike the stereotypical tourist trails which appear to bore Renaud, marks a particularly fitting backdrop. It takes its name from the Church of San Pier Maggiore, which was dismantled in the eighteenth century, leaving only its triple-arched facade. With superficial remnants of a more glamorous life, now the piazza consists only of humble bars and shops, and by night is inhabited by drinkers and sex workers: forms of life that appeal to Renaud. Nevertheless, the tables quickly turn for Renaud, and the symbolic clash concludes under the spectacular ruins of the Abbey of San Galgano, as Vadim points to ultimate unassailability of the entropic bourgeoisie. **➻Dom Holdaway**

Directed by Roger Vadim
Scene description: Desecrating social expectations
Timecode for scene: 1:22:42 – 1:25:46

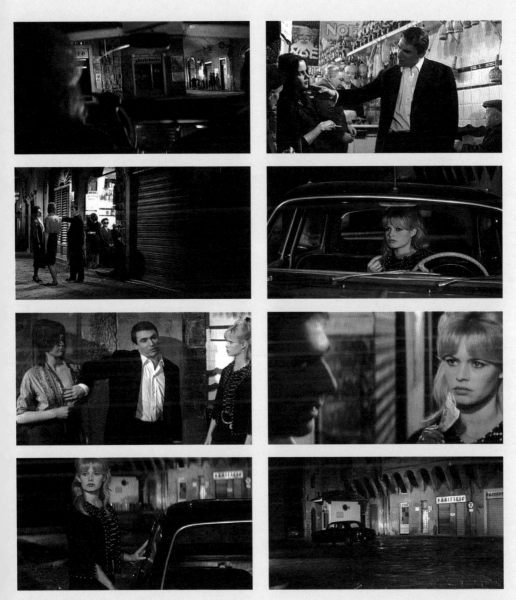

FAMILY DIARY/CRONACA FAMILIARE (1962)

Via delle Casine, a residential street near the centre of Florence

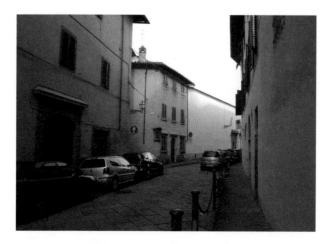

VASCO PRATOLINI SAID OF HIS NOVEL *Cronaca familiare* (1947) that it was 'not a work of fantasy' but rather 'a conversation between the author and his brother'. When Valerio Zurlini adapted Pratolini's novel for the screen, he captured its private, emotional tone through extended perspectival shots of the protagonist, Enrico (Marcello Mastroianni) as he wanders the streets of Florence. Zurlini's cinematographer, Giuseppe Rotunno, drew on the work of the mid-century Florentine painter Ottone Rosai in his depiction of the city, adapting Rosai's Futurism and post-Impressionism in order to depict Enrico's grief. Rotunno's visual, artistic correlative to Pratolini's intimate conversation shapes both the film's tone and its colour palette. We see this, for instance, in a scene that follows Enrico and his brother Lorenzo (Jacques Perrin) as they converse while walking along the Via delle Casine. Enrico, trying to articulate their strained sibling relationship, begins to raise his voice. 'Sure, sure, we're brothers. Lorenzo, I think I love you. But I don't want to love you just because we're brothers. We're brothers by chance. The important thing is to have the same tastes, the same ideas. To be friends.' The scene reveals the melancholy tension that divides the brothers and drives the film's severe narrative. That melancholy tone is reflected on the pale yellow facades of the buildings that surround the brothers as they talk – a yellow that calls to mind the dominant colour of Ottone Rosai's *Via Toscanella* (1922) and *Trionfo di una strada* (1930).
⟶ Charles Leavitt

Directed by Valerio Zurlini
Scene description: A heated conversation between two brothers
Timecode for scene: 0:02:15 – 0:06:20

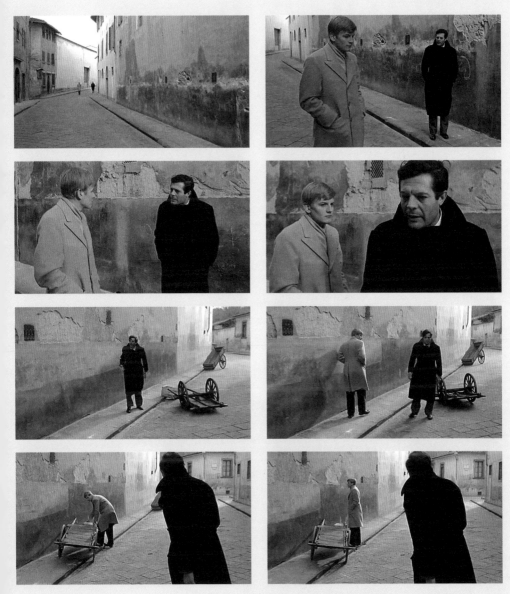

FLORENCE AFTER DARK

Cops, Crime and Serial Killers

Text by
DOM
HOLDAWAY

WHEN A LETTER ARRIVES to FBI agent Clarice Starling with a postmark from Las Vegas, her colleague wonders if 'Sin City' might be the hiding place of its writer, infamous serial killer Hannibal Lecter. Starling quickly dismisses the idea: 'Las Vegas would be the last place he'd be. It would be an assault on his sense of taste.' Instead, as we already know (from the first shots of the CCTV-style opening credits, which snap from Michelangelo's David to the Duomo), the chosen hideout for Lecter is Florence (or, for the most part, a fraction of Florence centred around the Piazza della Signoria). Unlike Vegas, Florence stands for art, knowledge and beauty, reflecting Lecter's own acute intelligence and taste. With this backdrop for much of the film, Ridley Scott's 2001 *Hannibal* (the sequel to *The Silence of the Lambs* [Jonathan Demme, 1991]) mixes the Tuscan city into complicated morals and anti-heroism, troubling the idealized artistic beauty that the surface of Florence epitomizes.

The second face of this Janus-like city that lurks beneath its artistic beauty has a long history, one of embittered political fighting and religious repressions during the Middle Ages, political assassinations during the reign of the Medici – committed in part by the De Pazzi family, ancestors of the unfortunate Florentine Inspector Rinaldo Pazzi (Giancarlo Giannini) in *Hannibal* – through to wars and fights for independence with several European nations and infamous bloodshed at the hands of the 'Monster of Florence' more recently. Many of these scenarios have been translated to the screen (*La cena delle beffe/The Jesters' Supper* [Alessandro Blasetti, 1941]; *Paisà/Paisan* [Roberto Rossellini, 1946]) and in particular the serial killings of young couples in their cars by the 'Monster' through the 1960s, 1970s and 1980s has had a notable influence on cinematic Florence. Some films adopt an historical approach, such as *Il mostro di Firenze/The Monster of Florence* (Cesare Ferrario, 1986), *L'Assassino è ancora tra noi/The Killer is Still among Us* (Camillo Teti, 1986); others less directly, such as Roberto Benigni's comic satire *Il mostro/The Monster* (1994), others merely through implication, for instance *La Sindrome di Stendhal/ The Stendhal Syndrome* (Dario Argento, 1996). As Ellen Nerenberg has noted, films like Benigni's comment as much on the fear of the killer that haunted Florence as on the incapacity of the police to re-instate safety and capture the murderer(s) (Nerenberg, p. 5). Filming in indistinct peripheries or film studios, these films situate the hidden face of criminality away from tourist Florence, and in among the city's inhabitants.

In addition to the representations of Florence's criminal history, the underbelly of the city has permeated international cinema too. *Up at the*

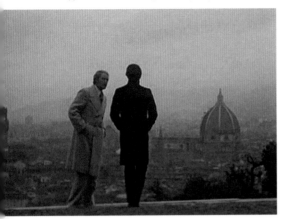

Villa, Philip Haas's 2000 adaptation of W. Somerset Maugham's novella, and Brian De Palma's 1976 thriller *Obsession* together depict alternatives to the city through the Anglo-American love affair with Tuscany. De Palma's film tells of blackmail and murder: New Orleans businessman Michael Courtland's (Cliff Robertson) wife and young daughter are kidnapped for ransom and eventually killed in a horrific accident. Courtland soon memorializes his family in a huge vault that is shaped identically to the Church of San Miniato, which stands on the hills above Florence. Tempted back to Italy some twenty years later by his colleague, Michael meets Sandra Portinari, an eerie doppelgänger of his deceased wife at the very same church. As the titular emotional 'obsession' develops, and the film moves towards its dramatic denouement, the historical Florence that was once the place of beauty and Michael's first love blurs and merges with its doppelgänger, revealing blackmail and corruption. *Up at the Villa* depicts the aristocratic British community in (and above) the city in 1938, using an accidental murder and eventual bribery by the English widow Mary Panton (Kristin Scott Thompson) to reveal the contradictions and falsehoods lived by the community. The backdrop of emergent, violent Fascism in the backstreets of Florence adds to the city's intimidating feel.

The main source of law and order in *Up at the Villa* is the Commissario Beppino Leopardi (Massimo Ghini), who stands rigidly for Fascist social principles, yet becomes corruptible when faced with his own past crimes, allowing Mary to bribe him. Essentially the character is an uncomplicated antagonist, yet the thin line between what's legal and illegal that Leopardi embodies reflects a relatively common motif in Florentine 'cops', which draws influence from the international detectives of noir and neo-noir crime-writing and cinema. Rinaldo Pazzi, in *Hannibal*, is a typically embittered chief inspector, who is even emasculated by Hannibal himself, interestingly, who comments on his re-assignment and demotion from the Monster of Florence case. Pazzi similarly blurs the legal and illegal, hiring a petty criminal to steal a fingerprint from Lecter, with tragic consequences; and opting to hand Lecter over to Mason Verger for a substantial reward, rather than to the FBI. In the complicated morals of *Hannibal* and of the city, this moral transgression must lead to a fitting and historically inspired end for Pazzi. Florence's moral ambiguities draw the cops closer to the criminals, creating the ideal cityscape for some of the most infamous international anti-heroes: Maurice Leblanc's 'gentleman thief' Arsène Lupin appears in Florence in *Signé Arsène Lupin/Signed, Arsène Lupin* (Yves Robert, 1959), and even Bonnie and Clyde are partly relocated to Florence in the Italian comedy re-make, *Bonnie e Clyde all'italiana* (Steno, 1982).

Dario Argento's cult classic *The Stendhal Syndrome* traces out the psychological corruption of a Roman detective, Anna Manni (Asia Argento), as she chases a serial rapist and killer. Manni begins the film in Florence on a lead, though she fast becomes a victim of his sexual assault and witnesses him murdering another girl, before escaping. Though she eventually overcomes him, the psychological trauma affects Manni deeply, and she literally begins to assume his characteristics. Florence, and in particular that same syndrome that led Stendhal to feel faint in the Basilica of Santa Croce in 1817, affect Manni identically in the opening sequences, first in the Uffizi Gallery, second in her hotel room. While she is in a surreal and dreamlike interaction with the gallery's famous works of art Manni is weakened, and the killer is able to make his move. In Argento's film, Florence's art patrimony therefore goes beyond a symbolic reflection of the city's beauty, becoming instead an accomplice to the killer, and cementing the inescapable connection between the two faces of the city. ✚

Up at the Villa... and Brian De Palma's 1976 thriller *Obsession* together depict alternatives to the city through the Anglo-American love affair with Tuscany.

LOCATIONS MAP

FLORENCE

Viale Filippo Strozzi

Viale Spartaco Lava

Viale Belfiore

Viale Fratelli Rosselli

Lungarno del Pignone

Via dei Vanni

Via Bronzino

17

19

22

21

16

FLORENCE LOCATIONS
SCENES 16-22

HARD TIMES FOR PRINCES/ LA CONGIUNTURA (1964)

LOCATION *Ponte Vecchio*

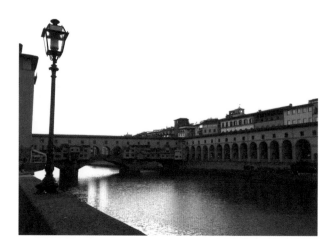

JANE (JOAN COLLINS) and Giuliano (Vittorio Gassman) stop in Florence on a road trip from Rome to Lugano, Switzerland. Cut to Jane's face smiling in front of the Ponte Vecchio. The camera draws back and the Ponte Vecchio appears again in the rear of the shot. The first view of the bridge is a mounted photograph, a prop for tourist souvenirs (a sign explains: 'Ponte Vecchio with guaranteed sun'). Like the photo reproduction of the bridge, Jane is faking a tourist experience. She is pretending to be on a romantic trip, but is actually taking advantage of Giuliano's diplomatic licence plates to smuggle cash over the Swiss border. When Giuliano pulls up in a new car, Jane's face shows panic. Unbeknown to him, the money is still hidden in his old car. In the sixteenth century, when the Medici family had the Vasari Corridor built across the Ponte Vecchio, they supposedly banished the butchers who traded there. They were replaced by goldsmiths, who now share the bridge with shops for tourists. Tourism and gold: the bridge provides a fitting backdrop for Jane's deception. She persuades Giuliano to spend a night in Florence, spinning a web of lies to keep them in the city while the car is fixed. As she speaks, the scene behind them of the twice repeated Ponte Vecchio is a visual pun on her schemings: a double crossing. **↠Natalie Fullwood**

Photo © Alberto Zambenedetti

Directed by Ettore Scola
Scene description: Jane, a woman who is trying to smuggle cash across
the Swiss border, has her photograph taken at the Ponte Vecchio
Timecode for scene: 0:31:00 – 0:32:23

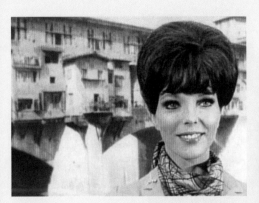 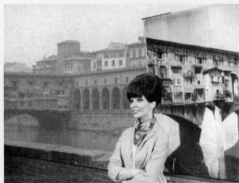

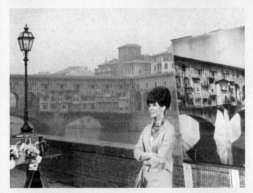 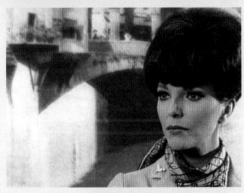

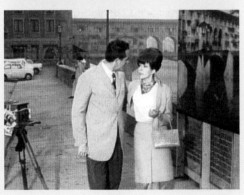 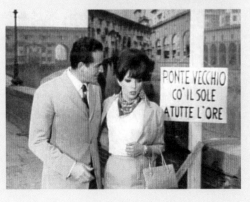

MISUNDERSTOOD/ INCOMPRESO (VITA COL FIGLIO) (1966)

LOCATION *Via Giovanni Antonio Sogliani*

IN A DIRECTORIAL CAREER that spanned more than forty years, Luigi Comencini became known as one of the great film-makers of childhood, from early films such as *Children in Cities/Bambini in città*, a 1946 documentary about the lives of children in post-war Italy, to his 1991 swansong *Marcellino*, a remake of the 1955 Ladislao Vajda film in which an abandoned baby is raised by monks and grows into a boisterous young boy. In 1966, Comencini adapted English writer Florence Montgomery's 1869 novel *Misunderstood* into a film starring Anthony Quayle as John Duncombe, an English diplomat working in Florence. The film focuses on Duncombe's relationship with his two young sons after the death of their mother; 4-year-old Milo (Simone Giannozzi) is his father's favourite as he reminds him most of his wife, while 8-year-old Andrea (Stefano Colagrande) seems unable to properly grieve, an attitude his father mistakes for coldness. The film was shot in various locations around Florence including in Viale Evangelista Torricelli where we find the Duncombe family villa and Lugarno Torrigiani where the boys go to school. In a later scene, we see Andrea walk along Via Giovanni Antonio Sogliani one balmy evening with two young girls he has met after catching a film at the cinema. His dismissive attitude toward his father and brother masks a profound sadness over the death of his mother. Comencini films the exchange in a single, unbroken shot that also manages to take in the Arno River in the background. **↝Pasquale Iannone**

Directed by Luigi Comencini
Scene description: Andrea meets two young girls as he leaves the cinema
Timecode for scene: 1:20:51 – 1:22:11

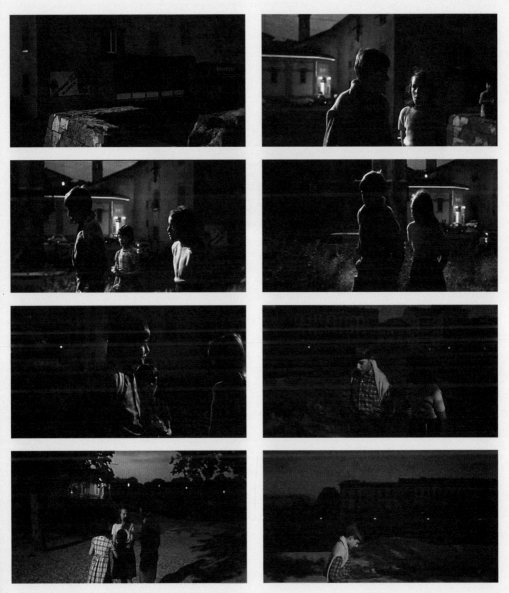

Images © 1966 Franco London Films, Istituto Luce, Rizzoli Film

THE SAILOR FROM GIBRALTAR (1967)

Piazzale Michelangelo

BASED ON THE EPONYMOUS 1952 novel by Marguerite Duras, *The Sailor from Gibraltar* shares many characteristics with Antonioni's 1960 *L'Avventura*. Like its lofty modernist predecessor, Richardson's film is a tale of alienation that centres on the disintegration of one couple and the possible creation of another, while telling the story of an ill-fated search for a missing character. Moreover, the characters are analogously colour-coded: blonde Englishwoman Sheila (Vanessa Redgrave) and brunette French widow Anna (Jeanne Moreau) share the attention of dark-haired, handsome Alan (Ian Bannen). Anna spends her life on her yacht searching for the mysterious titular sailor, who disappeared after their love affair. When Alan becomes intrigued by Anna's story and decides to join her in her quest for her long-lost lover, the two embark on a journey that takes them to the farthermost corners of the Mediterranean. The film opens with the arrival of Alan and Sheila in Florence, who explore the city separately. Richardson gets the obligatory sightseeing out of the way with a quick, almost frenetic montage of Sheila visiting the highlights while her voice-over recites one of Lorenzo De Medici's most recognizable poems, 'Quant'è bella giovinezza'/'How Beautiful is Youth' (*Canti carnascialeschi*, XV century), alternating one verse in Italian to its English translation. Perhaps aware of the fleeting nature of youth, as the poem suggests, the sprightly Redgrave makes the most of her stay and nimbly climbs the many stairs to Piazzale Michelangelo to rest her eyes on the famous vista. Like Alan, Richardson chose Moreau over his wife Redgrave, divorcing her in 1967. **•→Alberto Zambenedetti**

Photo © Alberto Zambenedetti

Directed by Tony Richardson
Scene description: Sheila climbs the steps to Piazzale Michelangelo
Timecode for scene: 0:05:22 – 0:06:14

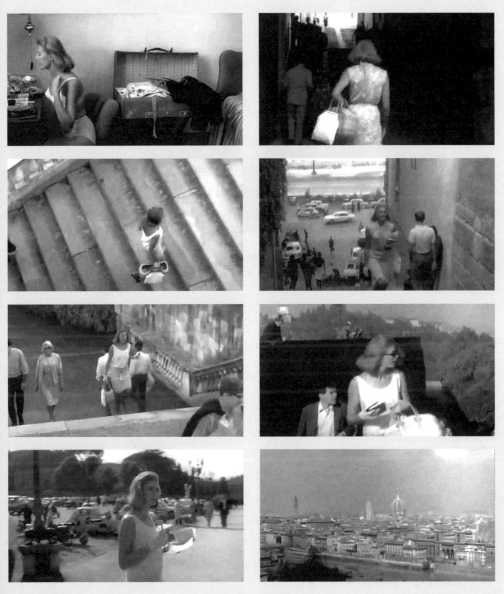

Images © 1967 Neil Hartley and Oscar Lewenstein for Woodfall Film Productions

THE CRAZY KIDS OF THE WAR/
LA FELDMARESCIALLA (1967)

LOCATION *Dome of Santa Maria del Fiore Cathedral*

1944 GERMAN-OCCUPIED FLORENCE, just south of the Gothic line drawn by Field Marshal Albert Kesselring as the last major line of defence against the Allies, serves as the setting for the first part of this Franco-Italian co-production. Three characters are trying to escape from a Nazi official (Francis Blanche): Rita, played by pop icon Rita Pavone, whose songs feature in the film; her neighbour Professor Fineschi (Mario Girotti, who was soon to adopt the pseudonym Terence Hill); and an American pilot disguised as a monk (Jess Hahn). An establishing shot from the professor's terrace uses Florence's most famous landmarks, the Dome of Santa Maria del Fiore Cathedral and Giotto's bell tower, to underscore the action's location, whose centrality is made redundant by Rita's words: 'It's splendid. We can see the whole city!' A wider shot, revealing the configuration of Fineschi's flat, is followed by a medium long shot showing the same cityscape. Brunelleschi's recognizable Renaissance masterpiece functions as the organizing element around which the whole scene unravels. It is nevertheless relegated to the background whereas the foreground establishes the film's central relationships and introduces a crucial plot element. Roughly reproducing the shape of the dome, two small red rockets are seen standing amongst test tubes and flasks, representing Fineschi's scientific invention, coveted by the Nazis. This architectural element is merely used to set up a hollow sense of place; in the same way throughout his war comedy, Steno mobilizes well-known historical motifs in parody of World War II dramas. **↦Marie-France Courriol**

Photo © Alberto Zambenedetti

Directed by Steno
Scene description: Rita, a Florentine innkeeper, introduces an American aviator to her neighbour, a scientist whose latest invention has to be hidden away from the Nazis
Timecode for scene: 0:14:16 – 0:16:25

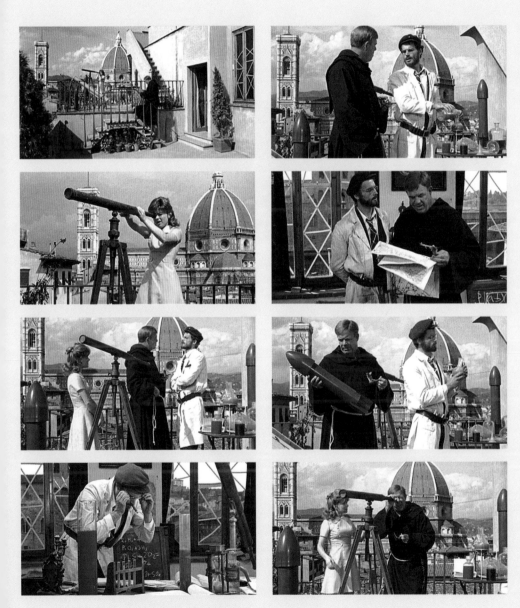

MY FRIENDS/AMICI MIEI (1975)

LOCATION *Via dei Renai*

ITALIAN COMEDY HAS OFTEN portrayed small cafes and bars as key venues in Italian social life – mostly involving activities such as playing cards or pool while making cruel hoaxes and impudent jokes on other regulars. *Amici miei* is the first instalment of a trilogy set in Florence that beautifully captures this provincial, irreverent world. The film follows a group of middle-aged friends, Mascetti (Ugo Tognazzi), Perozzi (Philippe Noiret), Melandri (Gastone Moschin), Sassaroli (Adolfo Celi) and Necchi (Duilio del Prete), who use Necchi's cafe on Via dei Renai (now a popular destination for the Florentine youth) as headquarters for their picaresque adventures. One of the film's funniest scenes occurs when the group stops by Necchi's cafe to pick him up before the gang's first escapade. While waiting in the car for Necchi, Perozzi and Melandri insistently honk until a traffic policeman approaches them. Mascetti then rushes out of the cafe to perform his 'supercazzola' joke in front of the agent. The 'supercazzola' is a nonsensical tongue-twister with sexual allusions that Tognazzi utters with great speed and impeccable seriousness to confuse his interlocutor. It recurs several times in the *Amici miei* trilogy, so much so that it has become a signature of Tognazzi's comedy. Finally, when Necchi also arrives and convinces the agent not to give them a ticket, everything seems to end well. Yet, while the group gets in the car to leave, Mascetti becomes really upset with Necchi for interrupting his 'supercazzola' joke. ➻*Marco Purpura*

Photo © Alberto Zambenedetti

Directed by
Scene description: Mascetti performs his 'supercazzola' joke
to tease a traffic policeman in front of Necchi's bar
Timecode for scene: 0:09:37 – 0:12:11

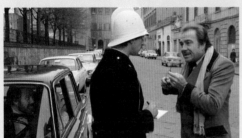
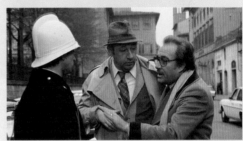
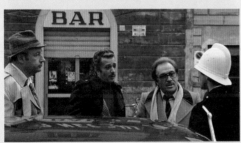
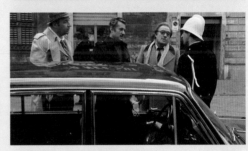
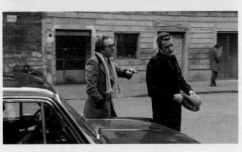

OBSESSION (1976)

Orsanmichele Church, San Gimignano (NB: Bernardo Daddi's "Madonna and Child")

BRIAN DE PALMA is often dismissed as a vulgar Hitchcock poser. Appropriately, then, *Obsession* deals with the implications of remoulding a vanished icon, an operation inherently dependent on an act of imposturous posing. Sixteen years after the death of his wife Elizabeth (Geneviève Bujold), New Orleans businessman Michael Courtland (Cliff Robertson) travels to Florence. Here, he meets art restorer Sandra Portinari (surnamed after Dante's Beatrice and also played by Bujold), who uncannily resembles his deceased wife. A plot punctuated by Michael's attempt to 'remake' Elizabeth ensues. In a meaningful scene, Michael approaches Sandra while she works at the restoration of Bernardo Daddi's "Madonna and Child". The painting is in the Church of Orsanmichele, but De Palma situates the encounter inside the Church of San Miniato al Monte, thus effectively conjuring up a double of Daddi's piece, whose blatant status as fallacious copy here mirrors Sandra's own deceiving act. Adding to the 'doubling' motif is the (fictional) reference in the scene to damage in the painting that has revealed an earlier draft underneath, which makes it difficult to label one layer more 'original' than the other, along with the (actual) fact that Daddi's *Madonna and Child* was conceived to replace another image of the Virgin that had previously adorned the church. Daddi completed the piece in a cleverly revivalist style as an act of homage and to keep the potency of the original alive through its substitute. De Palma appears to state this much about his relationship to Hitchcock.
➼ *Stefano Ciammaroni*

Photo © Elizabeth Williams

Directed by Brian De Palma
Scene description: Sandra works at the restoration of Bernardo Daddi's Madonna and Child
Timecode for scene: 0:35:08 – 0:39:28

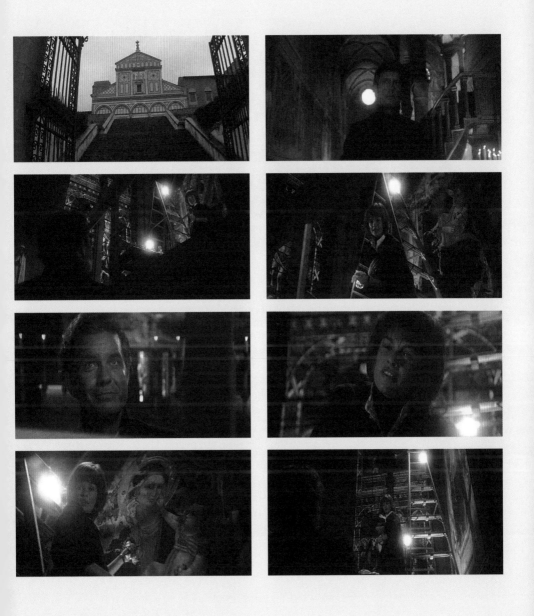

BOBBY DEERFIELD (1977)

Via dei Tornabuoni

AFTER A FELLOW DRIVER is killed during a race, laconic superstar Bobby
Deerfield (Al Pacino) begins to process the mortal dangers of life in pole
position on the Formula One circuit. To capture his peripatetic search
for meaning in a world of international stardom, director Sidney Pollack
leads the audience through a variety of European locations that reflect the
existential angst of the film's lead character. While visiting another driver
who was wounded in the same accident, Deerfield makes the acquaintance of
an enigmatic Swiss woman, Lillian (Marthe Keller), who is also convalescing
from an unknown illness. The distinction between these two incongruous
figures will frame the rest of the film: Lillian, vivacious and irreverent,
follows her every whim despite suffering from a fatal illness; Deerfield lives
only to test death behind the wheel, sleepwalking from race to race in a state
of self-conscious gloom. When they arrive in Florence where Lillian keeps
an apartment, Pollack highlights the difference between this odd-couple
through an extended tracking shot down Via dei Tornabuoni. Here, Lillian
interrogates Deerfield about his life in the limelight, questioning his identity
as an international celebrity. When she calls out his name on the street, fans
arrive in droves, leading both to delight in the 'plight' of fame.
⇢ Brendan Hennessey

Photo © Alberto Zambenedetti

Directed by Sidney Pollack
Scene description: Lillian challenges Bobby to remove his sunglasses
Timecode for scene: 1:05:41 – 1:08:08

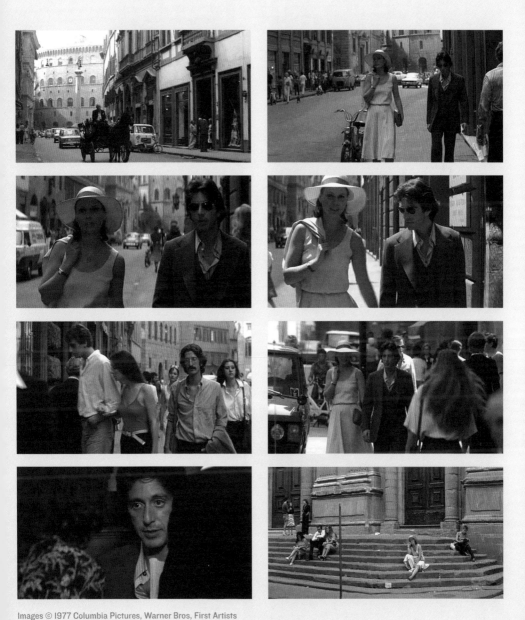

Images © 1977 Columbia Pictures, Warner Bros, First Artists

ROLLING HILLS, SCORCHING SUN

Text by
PASQUALE
IANNONE

Filming the Tuscan Countryside

IN A SHORT STORY ENTITLED 'Nostalgia' – which he later adapted for the screen in 1983 – the great Russian director Andrei Tarkovsky includes a beautiful description of the Tuscan landscape:

The sky is full of light, white clouds, similar to the pattern of fireworks. Their shadows slip over the hills and merge with the shadows of the trees. This alternating between light and shadow on the smooth surfaces of the hills – overlapping like ocean waves until the horizon – seems like the breath of life itself. The solemn rhythm of nature. (Tarkovsky, p. 248)

Tarkovsky's awe-struck response to Tuscany has been mirrored by hundreds if not thousands of other film-makers who have since the very beginnings of cinema been drawn to its timeless beauty.

The landscape of Tuscany includes the cities of Florence, Prato, Pisa, Arezzo, Siena, Lucca, Livorno and Pistoia as well as several other towns, making up a total area of around 23,000 sq. km. The spatial continuity between city and countryside makes for an extraordinarily scenic landscape and this has inevitably meant that most, though certainly not all, cinematic representations of the region (especially non-Italian productions) have limited themselves to picture-postcard prettiness. Tuscany, for instance, has long been a prime location for the heritage picture, films such as Henry James adaptations *A Room with a View* (James Ivory, 1985) and *The Portrait of a Lady* (Jane Campion, 1996) or Kenneth Branagh's 1993 version of Shakespeare's *Much Ado About Nothing*.

It is no surprise to find that it is film-makers from Italy that have consistently shown the different aspects of the Tuscan landscape. They make heritage films too, of course, but just as many have been made about peasant and farm life in the region. Pistoia-born Mauro Bolognini made *La Viaccia/The Lovemakers* in 1961 with Claudia Cardinale and Jean-Paul Belmondo. Adapted from an 1889 novel by Tuscan writer Mario Pratesi, the film tells of a farm boy's love for a city prostitute and was shot in and around Florence with director of photography Leonida Barboni providing some of cinema's most evocative black-and-white images of Tuscany. Other Tuscan auteurs include Mario Monicelli and Franco Zeffirelli: Viareggio-born Monicelli shot several films in the region including the smash-hit 1975 comedy *Amici miei/My Friends* while one of Zeffirelli's early works was *Florence: Days of Destruction* (1966), a documentary on the Florence flood of November

Above © 1975 R.P.A. Cinematografica, Rizzoli Film
Opposite © 1983 Opera Film Produzione, Rai 2

documentary on the Florence flood of November 1966, the worst in the area for more than four centuries. It happened while Zeffirelli was filming *The Taming of the Shrew* (1967) with Richard Burton and Elizabeth Taylor and Burton offered to provide the narration in both Italian and English, a gesture that proved invaluable in getting publicity for the relief effort.

The countryside around Siena, to the south of Florence was used memorably in Bernardo Bertolucci's *Stealing Beauty* (1996), the (typically Bertoluccian) story of a young American woman's trip to Italy to discover the identity of her father. The large farmhouse where Lucy Horman (Liv Tyler) stays is in San Regolo, round 25 km north of Siena. In the same year, English Italian director Anthony Minghella shot several scenes for his romantic war epic *The English Patient (1997)* in Tuscany. The sixteenth-century monastery Sant'Anna in Camprena provides the setting for scenes featuring Count László Almásy (Ralph Fiennes) and his nurse Hana (Juliette Binoche).

If we head north toward Pisa, we come to the town of San Miniato, famous for being the hometown of Paolo and Vittorio Taviani, arguably the most affecting chroniclers of the Tuscan landscape. In the Tavianis' films, landscape is charged with poetic and symbolic significance, often seeming to overcome their characters. The brothers have returned time and again to their home region, most memorably perhaps in *La notte di San Lorenzo/The Night of Shooting Stars (1982),* an extraordinary semi-autobiographical child's-eye view of World War II in which the sun-soaked Tuscan countryside is the site for horrific, surreal battles between Fascist and Allied forces. The film also recreates the wartime tragedy in San Miniato in which a bomb was set off in a local church killing more than fifty townspeople. The bombing, which the brothers had already examined in one of their early documentaries, was originally attributed to the Nazi occupiers. However, more than fifty years later, it was revealed to have been an incident of friendly fire. The scene was filmed in the Collegiata di San Andrea in the town of Empoli some 30 km west of Florence. The Tavianis would return to Tuscany for later films such as *Good Morning Babylon* (1987) and *Fiorile* (1993), but few other Italian features have imbued the stunning landscapes of Tuscany with a greater sense of foreboding than *The Night of Shooting Stars*. Which leads us back to Andrei Tarkovsky and his penultimate feature Nostalghia/*Nostalgia* (1983). It is the story of writer Andrei Gortchakov (Oleg Yankovsky) and his travels in Italy as he explores the life of eighteenth century Russian composer Pavel Sosnovsky. The film's central theme is homesickness, a feeling that undoubtedly shapes Tarkovsky's vision of the Tuscan countryside. 'It is the expression of an emotion, the one that is most deeply rooted in me, that I have never felt so strongly as when I left the Soviet Union' said Tarkovsky of the film.

And we Russians, for us nostalgia is not a gentle and benevolent emotion […] it is a sort of deadly disease, a mortal illness, a profound compassion that binds us not so much with our own privation, our longing, our separation, but rather with the suffering of others, a passionate empathy. (Tarkovsky 17 - *May 1983 interview*)

Tarkovsky's long takes move through space (and time) with characteristic languourousness and include several sequences filmed in and around the Bagno Vignoni Spa in San Quirico d'Orcia. The result is a film of melancholy beauty, one of those rare examples when a non-Italian film-maker has crafted a highly personal vision of the Tuscan landscape in all its beguiling complexity. ✥

It is no surprise to find that it is film-makers from Italy that have consistently shown the different aspects of the Tuscan landscape.

LOCATIONS MAP

FLORENCE

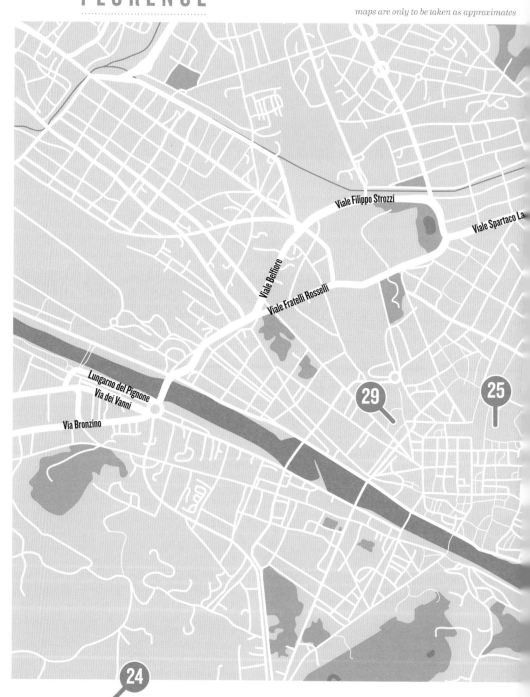

Viale Filippo Strozzi

Viale Spartaco La

Viale Belfiore

Viale Fratelli Rosselli

Lungarno del Pignone
Via dei Vanni

Via Bronzino

29

25

24

FLORENCE LOCATIONS
SCENES 23-29

23

26

Via Bolognese Nuova

Viale Giacomo Matteotti

Viale Antonio Gramsci

28

Viale della Giovine Italia

Lungarno del Tempio

27

STAY AS YOU ARE/COSÌ COME SEI (1978)

LOCATION *Villa La Pietra, Via Bolognese, 120, 50139*

A YEAR BEFORE Bernardo Bertolucci's explored the theme of incest in *La luna/Luna* (1979), Alberto Lattuada made *Stay As You Are*, the story of a middle-aged architect Giulio Marengo (Marcello Mastroianni) who embarks on an extra-marital affair with Francesca (Nastassja Kinski), a young student he meets in Florence. As their relationship develops, however, Giulio realizes that Francesca could be his daughter from a previous relationship. Lattuada shot the film in various locations in the centre of Florence, including Piazza San Giovanni and Piazza San Marco but the film opens with Giulio walking through the spectacular grounds of Villa La Pietra. Built in 1460, the villa was owned by the family of English poet and historian Sir Harold Acton from 1908. Acton had links with the Bloomsbury group and over the years a plethora of prominent artists, writers and politicians enjoyed his family's hospitality at La Pietra. After Acton's death in 1994, Villa La Pietra was bequeathed to New York University where it is currently home to the NYU Florentine study abroad programme. In Lattuada's *Stay As You Are*, we see Mastroianni's Giulio explore the gardens around Villa La Pietra as the opening credits roll, accompanied by Ennio Morricone's tender main theme. He comes across Francesca reading on the steps and asks her the whereabouts of the gardener before offering her a lift to the city centre.
◄Pasquale Iannone

Directed by Alberto Lattuada
Scene description: Giulio Marengo walks around Villa La Pietra
Timecode for scene: 0:00:00 – 0:03:10

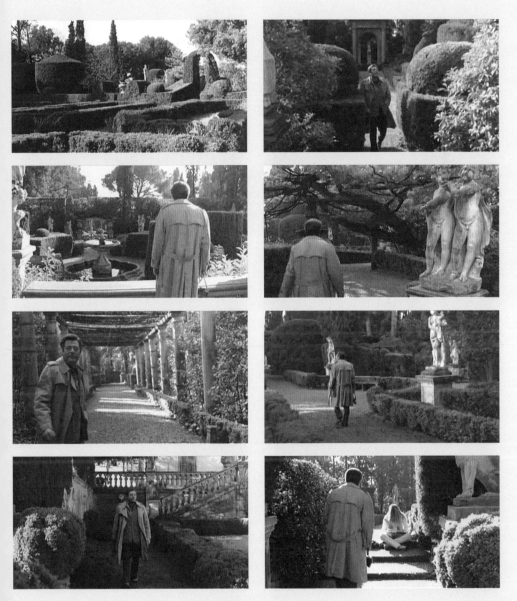

THE MEADOW/IL PRATO (1979)

Piazza della Cisterna, San Gimignano (Siena)

ALTHOUGH FLORENCE OFFERS an important sequence featuring Rossellini's *Germany Year Zero/Germania, anno zero* (1948), the nearby San Gimignano ('Town of Fine Towers') has pride of place in the Tavianis' *Il Prato*. The film is a triangular love story that finishes badly. Giovanni (Saverio Marconi), a young Milanese magistrate, goes to San Gimignano to oversee the transfer of some property. Once there, he meets Eugenia (Isabella Rossellini), a recent anthropology graduate who performs street theatre with the town's children. Sparks fly when Giovanni and Eugenia meet (visualized by a cataclysmic thunderstorm), but Eugenia maintains her relationship with Enzo (Michele Placido). San Gimignano's instantly recognizable Piazza della Cisterna centres both the town and – despite its pastoral title – the film. Giovanni first sees Eugenia, high upon her stilts and surrounded by the troupe of children, in the piazza and Enzo is confronted by the municipal police at a later performance there. While performing, Eugenia injures herself. As she recovers, Giovanni tells her (and Enzo) a tale like the Pied Piper, occasioning the elaborate fantasy set, judging by the costumes, in medieval times. The imposing cistern, which dates to the eighth century, appears prominently among the dancers who gyrate around its perimeter. Anticipating an episode ('La giara') in the Tavianis' *Kaos* (1984), which also concerns the anthropology of place, the piper whips the townsfolk into a frenzy. Their fury contrasts with the serenity of the piazza's towers, so representative of San Gimignano. The dance, like the love triangle, threatens the fabric of society and Eugenia is at the apex of both. •►**Ellen Nerenberg**

Photo © Christopher J. Peters (Flickr)

Directed by Paolo and Vittorio Taviani
Scene description: In an elaborate fantasy scene, Eugenia plays the role of the Pied Piper
and the townsfolk of San Gimignano dance until their imagined death
Timecode for scene: 0:55:13 – 1:01:36

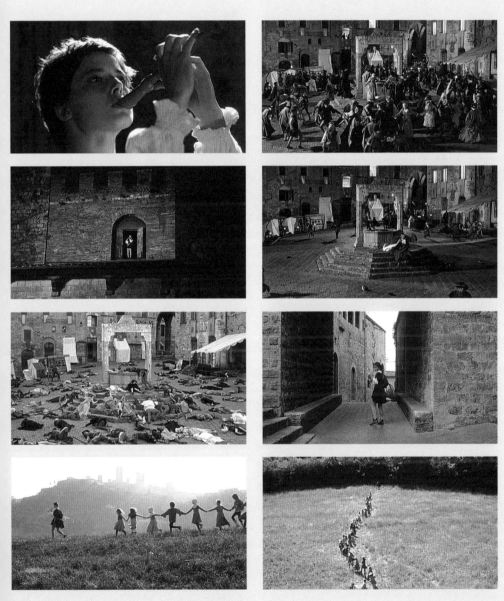

I'M STARTING FROM THREE/ RICOMINCIO DA TRE (1981)

LOCATION *Piazza dell'Olio (Piazza Duomo), intersection Via dei Pecori*

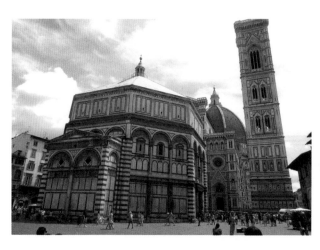

TROISI'S FIRST FILM (which he wrote, directed and starred in) impressed the critics and crowds and won the David di Donatello for Best Film and Troisi for Best Actor in 1981. In this picaresque film about a young Neapolitan interested in seeing a bit of the world (or the rest of Italy, anyway), Gaetano (Troisi), is asked constantly whether he is immigrating to Florence from his native city. More accurately, the various people he meets en route to Florence and once there simply assume he is moving north for better work prospects. Although Gaetano claims to want simply to travel, he curiously sees very little of monumental Florence, which is why this scene is so interesting. With Frank, the American priest (Vincent Gentile), in Piazza dell'Olio, at the corner of Via dei Cerettani and the Piazza, he sees Marta (Fiorenza Marchegiani), the young hospital worker he meets before arriving for an extended visit to his aunt in Florence, but whose name he did not catch. So that he can 'run into her casually on purpose', Gaetano takes off down Via De' Cerretani, rounds the corner at Via dei Vecchietti, and then another at Via dei Pecori to 'bump into' Marta at the opposite intersection of Piazza dell'Olio. As Gaetano and Marta exchange names and coordinates, we see the Baptistry, Giotto's Campanile and the right edge of the Duomo in the background. Not filmed symmetrically, the 'monumental' side of Florence not centred and largely unacknowledged in the background, this scene is slightly 'off' in the way that Gaetano is whimsically 'off' throughout the film, something hinted at in the film's title, which reprises Gaetano 'beginning again from three', and not the more customary zero. It appears that life really will 'begin again with three': as the film closes, it appears Gaetano will emigrate to Florence to stay with Marta and her as yet unborn child. •➤ **Ellen Nerenberg**

Photo © Alberto Zambenedetti

Directed by Massimo Troisi
Scene description: Gaetano, a Neapolitan tourist visiting Florence, 'runs into' Marta on purpose
Timecode for scene: 0:23:17 – 0:24:50

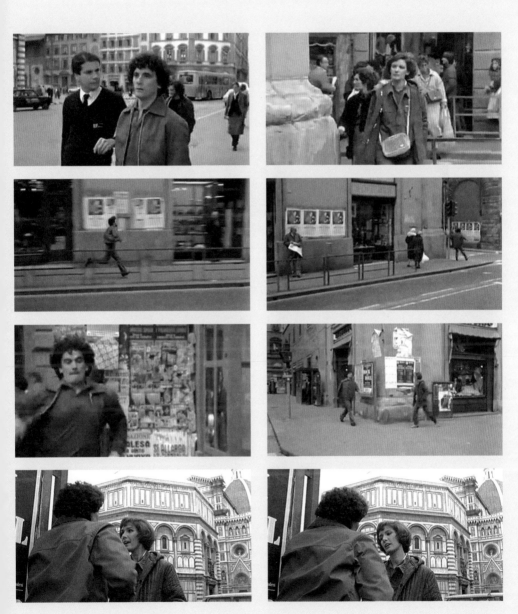

WEST OF PAPERINO/AD OVEST DI PAPERINO (1982)

LOCATION The intersection of Viale Matteotti and Piazza della Libertà, by the (now removed) pedestrian bridge

AN URBAN ROAD MOVIE that trades the open American spaces for the cobblestones of Florence, *West of Paperino* was the first film by comedy group 'I Giancattivi', here in its best-known formation: Alessandro Benvenuti, who scripted and directed the film, Athina Cenci and Francesco Nuti. The film follows three eccentric characters – Sandro (Benvenuti), who works at a local radio station, Marta (Cenci), an artist with a vivid imagination, and Francesco (Nuti), an unemployed mama's boy – as they wander, over the span of one day, through an understated Florence. In this scene, a prank backfires and the characters are chased by two city policemen across the pedestrian bridge that once straddled Viale Matteotti where it meets Piazza della Libertà, and are pushed back into the city centre. In the 1860s the old city walls were demolished to make room for the 'Viali di Circonvallazione', a ring of boulevards worthy of a modern capital (which Florence was from 1865 to 1871), that sharply demarcated the boundary between the historical centre and the modern, post-unification city. However, Benvenuti's camera only captures the inside of the porticos that run along Piazza della Libertà and the steel footbridge across Viale Matteotti, rejecting the monumentalizing effort of this urban plan. Likewise, the historical centre is carefully shorn of its aesthetic allure. Instead of embracing the vertical movement imposed upon the tourist's gaze by monumental Florence, the perspective is kept firmly at street level, to reveal an alternative city of drug addicts and small-time swindlers, and shabby cafes and run-down tenements. •➤*Luca Somigli*

Photo © Alberto Zambenedetti

Directed by Alessandro Benvenuti
Scene description: As a prank backfires, Sandro, Marta and Francesco are chased by two city policemen across a pedestrian bridge spanning Viale Matteotti
Timecode for scene: 0:31:45 – 0:35:10

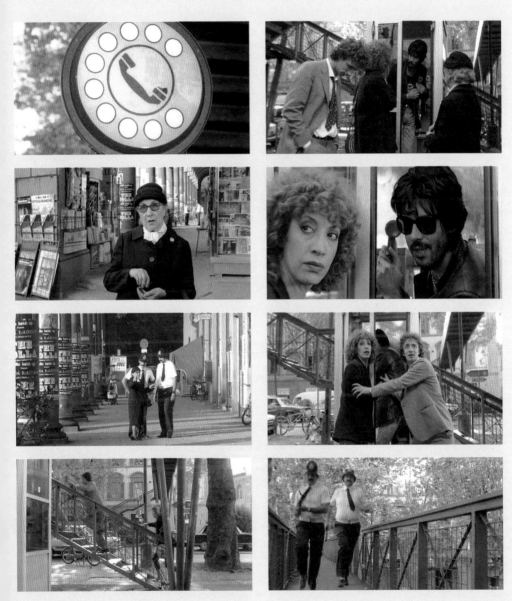

ALL MY FRIENDS: PART 2/ AMICI MIEI: ATTO II (1982)

LOCATION *Porte Sante Cemetery*

RELEASED IN 1982, Mario Monicelli's *All My Friends – Part 2*, is one of the last examples of *commedia all'italiana* (Italian-style comedy), a genre that mixed drama, social satire and bittersweet laughter. The film opens at the Porte Sante Cemetery, where Raffaello Mascetti (Ugo Tognazzi), Guido Necchi (Renzo Montagnani), Rambaldo Melandri (Gastone Moschin) and Alfeo Sassaroli (Adolfo Celi) meet to reminisce about their adventures by the tomb of Giorgio Perozzi (played in the first instalment of the trilogy by Philippe Noiret). Built in 1848 by architect Niccolò Matas, and expanded in 1864 by Mariano Falcini, the monumental cemetery is enclosed within the walls of the Basilica of San Miniato al Monte, which stands atop one of Florence's highest hills. As Mascetti walks from the flower shops outside the church toward the cemetery, the camera lingers on the spectacular view of the city. The layering of structures and the visual line-matching of tombstones and trees shows the area's lyrical beauty and presents Porte Sante as a place of memory. The irreverent gang, reunited by their friend's grave, begins to parody the tradition of verse-writing that finds inspiration in the serenity of cemeteries and in the memory of great men of the past. They reminisce about Perozzi's serial adultery and his ridiculous pranks, reawakening in themselves the desire to create havoc. Despite the apparently humorous tone of the scene, the setting strongly suggests the idea of death, which recurs throughout the film. ✦*Camilla Zamboni*

Photo © Alberto Zambenedetti

Directed by Mario Monicelli
Scene description: The gang reunites by the tomb of Giorgio Perozzi
Timecode for scene: Opening credits

A ROOM WITH A VIEW (1985)

Church of Santa Croce

IN JAMES IVORY'S 1985 adaptation of E. M. Forster's 1908 novel *A Room with a View*, Lucy Honeychurch (Helena Bonham Carter) and her chaperone, her older spinster cousin Miss Bartlett (Maggie Smith), visit the city of Florence as part of the traditional British Grand Tour of Italy. Following the suggestion of a fellow traveller, novelist Eleanor Lavish (Judi Dench), Lucy leaves her precious Baedeker guidebook at the *pensione* (hotel) to experience a more spontaneous visit of the city. As the title card 'In Santa Croce with no Baedeker' prepares the viewer for the episode, an external still shot of the basilica offers a postcard view of the location. The camera follows Lucy arriving at the building from the northern side of the piazza, swiftly climbing the staircase and entering the church. Inside, in a single shot, the camera first shows Lucy from above and then, as she walks toward the main nave, lowers to follow her in a long and very long-shot to emphasize the magnificence of the church. Built in the fourteenth century, Santa Croce is indeed the largest Franciscan church in the world, and, with the Duomo, a Florentine landmark. In addition to a place of worship, it is the burial location for illustrious Florentines and Italians. Yet Giotto's thirteenth-century frescoes portraying the life of Saint Francis in the Bardi Chapel are the main attraction. Using postcard-style close-ups of the frescoes, Ivory lets his film takes over the role of Baedeker, guiding the viewers in appreciating Florence's works of art.
⟿ Barbara Garbin

Directed by James Ivory

Scene description: Lucy visits the church 'In Santa Croce with no Baedeker'

Timecode for scene: 0:14:58 – 0:18:51

Images © 1985 Ismail Merchant

ALL MY FRIENDS: PART 3/ AMICI MIEI: ATTO III (1985)

LOCATION *Piazza Santa Maria Novella*

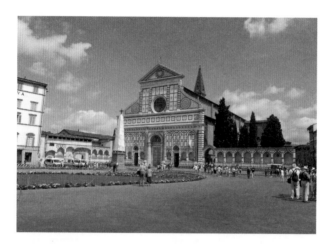

THE THIRD FILM of the saga, directed by Nanni Loy, marks the exile of the characters from the Florentine city centre. The action is displaced to the surrounding hills, following Mascetti's (Ugo Tognazzi), Necchi's (Renzo Montagnani) and Melandri's (Gastone Moschin) voluntary retreat to a retirement house. The mischievous fun they are having culminates when they volunteer as crossing guards for a school at Piazza Santa Maria Novella in the centre of Florence. The ageing friends' childish prank consists of giving chaotic instructions to drivers and intentionally creating a gigantic traffic jam on the square, which had not yet been pedestrianized. Delimited by the Basilica of Santa Maria Novella, with its coloured marble facade designed by Renaissance architect Leon Battista Alberti, and the Loggia dell'Ospedale di San Paolo where the school is situated, the square is invaded by buses and cars, thus giving the sequence its grotesque tone and underlining the joyous transgression at the core of the characters' actions. Instead of focusing on their historical or aesthetic values, the shots reverse shots of these iconic locations function as landmarks in the trilogy's internal history, inserting the episode into a topography of memories. The square is in fact situated only a few blocks away from the saga's historic location, Santa Maria Novella station, home to the characters' most memorable prank (that is, slapping train passengers from the platform). Their return to Florence therefore constitutes an attempt to rejuvenate themselves – this finds expression also in their association with the flock of unruly children streaming out from the Loggia's portico. •➤*Marie-France Courriol*

Photo © Alberto Zambenedetti

Directed by Nanni Loy
Scene description: *The friends volunteer to be crossing guards for a school at*
Piazza Santa Maria Novella, creating chaos and an enormous traffic jam
Timecode for scene: *1:21:29 – 1:23:15*

Images © 1985 Luigi De Laurentiis, Aurelio De Laurentiis

BREAD, WINE AND CELLULOID

Tuscan Cuisine at the Movies

Text by BRENDAN HENNESSEY

SPOTLIGHT

CINEMATIC MEDITATIONS ON 'foodways' – behaviours, rituals and practices surrounding food – reflect Italian culture's iconic gastronomic heritage known the world over. It is, therefore, not surprising that food, its preparation, presentation and consumption, appears frequently in films set in Tuscany, even in those not necessarily categorized as 'food films'. In many of these films, food serves to bolster a regional specificity, with typical plates presented to suggest a local geographic space exhibited in the form of cuisine. To this regional identity, one might add how eating carries distinct symbolic, metaphysical and spiritual values. It is not only an emblem of an area's acclaimed cooking, but also the joy, anxiety, desire and deprivation experienced by its people. From the realistic to the symbolic, examples of food imagery attest to the range of meanings that can be communicated through portraits of food, eating, cooking and cleaning up to convey emotions and motivations of main characters. Captured on film, Tuscan kitchens and dining rooms of taverns, restaurants and homes stage an array of dramatic tensions that mark important narrative sequences, especially those that focus on family and group dynamics.

For Italian cinema, cooking and eating trace the nation's historical progression from the hunger of the immediate post-war period to the relative abundance of the 1970s and beyond. In a short period, Italy transitioned from post-war devastation, seen in films like *Roma città aperta/ Rome, Open City (Roberto Rossellini, 1945)* and *Ladri di biciclette/The Bicycle Thieves (Vittorio De Sica,1948)* to the status of world economic power shown in *La dolce vita* (Federico Fellini, 1960) and *Il Sorpasso/The Easy Life* (Dino Risi, 1962).

The nation's newfound affluence is part of one of the most memorable Italian films set in Florence, *Amici miei/My Friends* (Mario Monicelli, 1975), the story of a group of middle-aged pranksters bent upon collective tomfoolery. The recurring scenes of dining in Amici miei distance the film from the stark portrayals of hunger that characterized many post-war feature films, presenting a portrait of wealth that will define the more decadent 1970s. This manifests itself in the form of the sformato di maccheroni: a huge pasta-pie made from baked maccheroni. We first witness the sformato in a hospital room occupied by four inpatients participating in choral foolishness as they dine. The sformato reappears in a central sequence when it is meticulously prepared by Melandri (Gastone Moschin) in hopes of wooing the fair Donatella (Olga Karlatos) with his culinary acumen. The sformato becomes fuel for perhaps the most iconic sequence in Italian comic cinema, when the group descends upon Florence's Santa Maria Novella station to impudently slap the faces of departing travellers on a train.

Another group of characters, this time artists instead of tricksters, surrounds the tables in *Stealing Beauty* (Bernardo Bertolucci, 1996), where visual, literary and culinary arts entwine. When the teenaged Lucy (Liv Tyler) returns to Tuscany in the wake of her mother's suicide, she becomes a member of a creative entourage that has collected at a rural farmhouse in the hills outside of Siena. Early in the film, this garden of earthly delights is pictured as the backdrop to the breakfast table, where Lucy becomes the source of immediate interest – erotic and otherwise – for the collection of artists who reside there. Food becomes the singular creative endeavour that is shared by all,

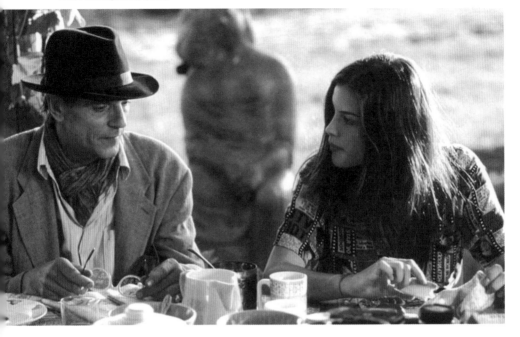

Above © 1996 Fiction Films, France 2 Cinéma,
Jeremy Thomas Productions

and while some write and others sculpt, everyone eats and drinks. Mealtimes are also a prelude to the group's nocturnal activities, where the consumption of dinner is a sensual appetizer for excess, including alcohol, drugs and sex that soon follow. A similar surrogate family also appears in *Under the Tuscan Sun* (Audrey Wells, 2003), where mealtimes become an opportunity for Frances, the film's lonely protagonist, to forge a new family bond to replace the one that she lost when her husband abandoned her for a younger woman. Cooking mirrors Frances's spiritual healing, a process that takes place over the course of months while she searches for the next chapter in her personal and creative life in the hillside outside of Cortona. The despair of her first winter in Italy is overcome when she begins preparing sumptuous dishes for the Polish labourers who are helping to rebuild her Tuscan villa. 'My prayers to San Lorenzo were quickly answered,' she says of the patron saint of cooks, 'I realized I already had someone to cook for … plenty of someones.' What follows

For Italian cinema, cooking and eating trace the nation's historical progression from the hunger of the immediate post-war period to the relative abundance of the 1970s and beyond.

is an extended montage in which Frances lavishes her guests with wine, ribollita, roast pears and prosciutto and melons. This family dynamic is also at the centre of *Tredici a tavola/Thirteen at the Table* (Enrico Oldoini, 2004), where a flashback to his family villa near Livorno illuminates memories of summer love lost for Giulio (Giancarlo Giannini), now middle-aged. The film's title derives from an old family superstition that thirteen people at the dinner table is either one too many or one too few. When that unlucky extra is Anna, the beautiful daughter of a family friend, this extra mouth to feed becomes the love interest of Giulio and his brothers. Here, mealtimes provide Giulio with the opportunity to observe and approach Anna whose place within the family unit represents a potentially volatile erotic element, threatening to pit brother against brother. When memories give way to the present, Giulio rekindles a relationship with his adult daughter over wine and sumptuous plates of pasta at the seaside getaway of his youth.

In all of these films, cooking and eating become theatrical events and the table transforms into a dramatic nucleus around which individual, societal and family conflicts revolve, where conviviality intermingles with discord, and where Tuscan landscapes meld with foodscapes to bring unique portraits of the countryside and its food into view. ✢

FLORENCE

maps are only to be taken as approximates

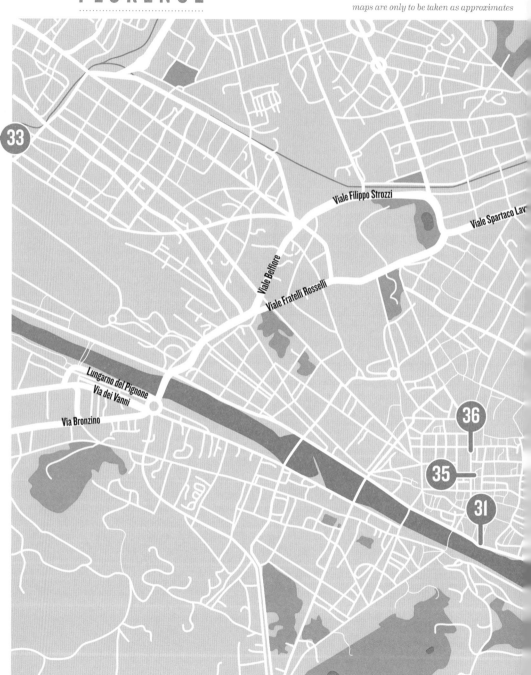

FLORENCE LOCATIONS
SCENES 30-36

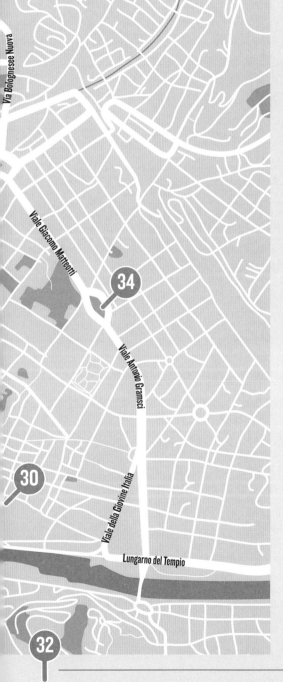

EVERYBODY'S FINE/STANNO TUTTI BENE (1990)

LOCATION *Attic Apartment in the building
on the corner of Via Torta and Via Giuseppe Verdi*

IN TRAVELLING TO VISIT his five grown children scattered throughout
the peninsula in Tornatore's *Everybody's Fine*, Matteo Scuro (Marcello
Mastroianni), a widower and retired clerk from a small Sicilian town, takes
the viewers to some of the most beautiful Italian cities. In the Florentine
sequence, his daughter Tosca (Valeria Cavalli) hosts him in a spacious
apartment with spectacular views of Santa Croce. Although initially
impressed with the penthouse, Matteo quickly diverts his attention to the
roof-tiles on the surrounding buildings, for him visibly more endearing than
the marvellous cathedral. Florence's rooftops are as much a trademark of the
city as its churches, monuments and historic buildings. Indeed, Florence's
historic centre is a UNESCO World Heritage Site since 1982: the entire urban
complex, with its outstanding buildings and artworks, is deemed a patrimony
for humanity. Highly eloquent is therefore the contrast, in the following scene,
between the marvellous view of the city's historic centre – with its red ochre
rooftops – and the headless bodies of the anonymous lingerie models. As the
scene shows, rather than a successful theatre artist and haute couture model,
Tosca is a broke single mother who has to pose in skimpy underwear to make
ends meet. In fact, all five of Matteo's children are much less successful,
professionally and personally, than he believes. Yet, blinded by his paternal
love and ambition, Matteo is unable and unwilling to see the reality and
prefers, even when eventually confronted with the truth, to persevere in
believing that *everybody's fine*. ◆**Barbara Garbin**

Photo © Alberto Zambenedetti

Directed by *Giuseppe Tornatore*
Scene description: *View of Santa Croce*
Timecode for scene: *0:46:18 – 0:53:00*

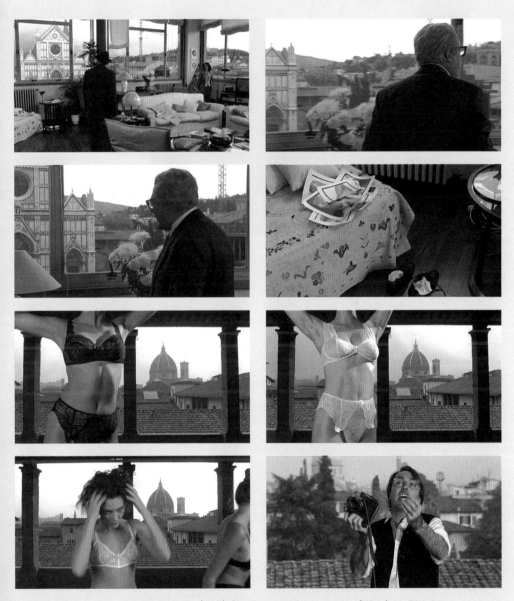

Images © 1990 Angelo Rizzoli Per Erre Produzioni (Roma), Silvio Berlusconi Communications (Milano), Les Films Ariane

THE STENDHAL SYNDROME/
LA SINDROME DI STENDHAL (1996)

LOCATION *Caravaggio's Head of Medusa, Sala del Caravaggio, Uffizi Gallery*

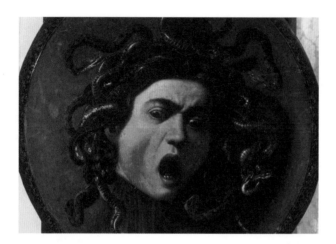

MICHELANGELO MERISI DA CARAVAGGIO and Dario Argento are evidently passionate about beheadings. Caravaggio's "Judith Beheading Holofernes" (1599), "Salome Receives the Head of St John the Baptist" (1607) and "The Beheading of St John the Baptist" (1608) all feature images of decapitation, as do Argento's *Four Flies on Grey Velvet/4 mosche di velluto grigio* (1972), *Deep Red/Profondo rosso* (1975), *Inferno* (1980) and *Phenomena* (1985), to only name a few. In *The Stendhal Syndrome*, Asia Argento plays Anna Manni, a detective in pursuit of a serial killer. The opening scene has Anna wander erratically around the tourist-choked rooms of Florence's Uffizi Gallery, a pretext for Argento's typically roving camera to duly take in many of the museum's most iconic treasures. It is however Caravaggio's *Head of Medusa* that the camera obliges the spectator to gaze at most forcefully, through a prolonged zoom shot that gets us close enough to register the horror in the eyes of Medusa, its head severed but still conscious. In this piece, which was commissioned to Caravaggio as a gift for the Grand Duke of Tuscany, the artist appears to catch Medusa at the very moment of self-recognition, as if the shield of Perseus had worked as a mirror, causing Medusa to fall prey to its own horrific and petrifying image. Argento's fans will be quick to note that mirrors, and with them the horror of self-recognition – of exhuming from the distant past the original sins and traumas responsible for triggering unspeakable violence – are the signature obsession of the Italian horror maestro.
•◦ *Stefano Ciammaroni*

Directed by Dario Argento
Scene description: *While Anna wanders around the Uffizi Gallery,*
Argento's camera pauses on Caravaggio's Head of Medusa
Timecode for scene: *0:03:05 – 0:06:40*

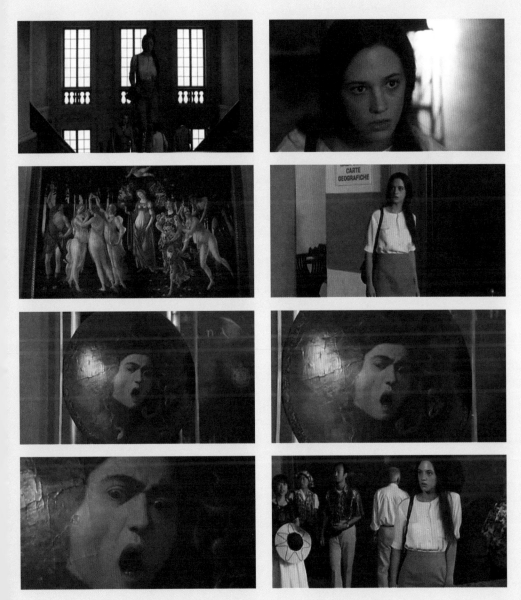

Images © 1996 Dario Argento, Giuseppe Colombo (a Medusa Film production realized by Cine 2000)

ELECTIVE AFFINITIES/LE AFFINITÀ ELETTIVE (1996)

LOCATION *San Miniato al Monte*

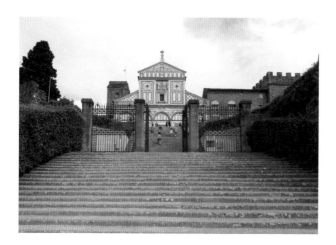

THE LONE FLORENTINE LOCATION in *Elective Affinities* – San Miniato al Monte – is highly significant. Based on Goethe's 1809 novel, *Elective Affinities* tells the story of two couples, Eduardo (Jean-Huges Anglade) and Carlotta (Isabelle Huppert) and Ottone (Fabrizio Bentivoglio) and Ottilia (Marie Gillain). As in Goethe's novel, a scientific principle of recombined elements corresponds to the couples' reordering: (A + B, Eduardo and Carlotta) and (C + D, Ottilia and Ottone) transform into (A + D) and (B + C). San Miniato al Monte appears early on as the setting for Eduardo and Carlotta's wedding. The narrator (Giancarlo Giannini) observes that the church is the couple's favourite and that Carlotta especially appreciates its geometric perfection. The Tavianis carefully frame this church, which, built in 1018 and sitting triumphantly atop Florence, features a famed Romanesque facade visible from all points of the city. The lower part of the facade shows the harmonious marriage of white and black stone and the directors take their time showing the inlaid marble. A slow zoom on another feature, a delicate intersection of three spheres, also underscores the harmony of the church's composition. The geometric perfection of the Romanesque building is counterpoint to the fundamental interrogation of the Enlightenment that so interested Goethe. The story is transposed from Weimar to Italy and the directors capitalize, as they did in *Allonsanfan* (1974), on the radical social reordering of Europe during the wars establishing the first French Empire. ➦ *Ellen Nerenberg*

Photo © Alberto Zambenedetti

Directed by Paolo and Vittorio Taviani
Scene description: Carlotta and Eduardo, one of the two couples
orchestrating the film's plot, are married in San Miniato al Monte
Timecode for scene: 0:05:02 – 0:05:32

THE PORTRAIT OF A LADY (1996)

LOCATION *Palazzo Pfanner, Lucca*

HAVING INHERITED a substantial sum from her uncle, Isabel Archer (Nicole Kidman) travels to Italy where she first meets her fellow American expatriate Gilbert Osmond (John Malkovich). Eventually his proposal will better those of Caspar Goodwood and Lord Warburton, and the two will marry and move to Rome. But before the couple meet, Osmond is visited in his Tuscan villa by his ex-lover and friend of Isabel: the Machiavellian Madame Merle. In her adaptation of Henry James's novel (1880–81), Jane Campion shoots Osmond's Florentine villa at the seventeenth-century Palazzo Pfanner, in the neighbouring town of Lucca. During Madame Merle's visit, in which she introduces Osmond to the idea of marrying Isabel, and her fortune, Campion plays cunningly with chiaroscuro lighting and interior/exterior space to symbolize the characters and their amoral scheming. The palazzo is first shot from a dizzying low-angle exterior, constructing an extravagant if superficial impression of Osmond, in the same seductive light that will fool Isabel. Campion cuts to a brief shot of his daughter, Pansy, set in the outside light indicating her free spirit, yet the bars of the balcony that mask our view symbolize the ultimate prison-like restriction that her father will impose. As Campion cuts inside, the bright exterior light cuts to a dim shade, a darkness that will come to characterize Osmond's suffocating repression of his wife and daughter, and one under which Madame Merle is able to communicate with her ex-lover, and persuade him of the virtues of Isabel. **⚭ Dom Holdaway**

Photo © Claudio Pedrazzi (Panoramio)

Directed by Jane Campion
Scene description: Osmond and Madame Merle scheme
Timecode for scene: 0:33:42 – 0:41:19

TEA WITH MUSSOLINI (1999)

Elizabeth Barrett Browning's grave at the English Cemetery

FRANCO ZEFFIRELLI'S *Tea with Mussolini* follows the vicissitudes of an eclectic group of elderly English women living in Florence in the decade between 1935 and 1945. Nicknamed 'the Scorpions' by the Italians for their stinging wit, the ladies spend their time mostly gossiping, drinking tea and enjoying the artistic beauty of the city, until Italy's declaration of war to England transforms them from distinguished guests into enemies of the nation. In choosing Florence as their adoptive city, the ladies followed the footsteps of illustrious predecessors. Among them was English poet Elizabeth Barrett Browning, who spent the last years of her life in the city and is buried there. To celebrate this genealogy, the entire expatriates community visits her tomb every year on the anniversary of her death. The opening scenes show a cheerful group of elegant English people walking through the city towards the poet's burial site in the English Cemetery. Founded in 1827 by the Swiss Protestant Church to bury people who were neither Jews nor Catholics, the cemetery hosts deceased from several nations, but the prevalence of English people explains the nickname. Before the tomb, Lady Hester (Maggie Smith), widow of the former British Ambassador in Italy, celebrates the poet as symbol of the marriage between the two countries. Then, the artistic mind of the group Arabella (Judy Dench) recites a poem to honour the birth in Florence of Browning's only child, in a hymn to British motherhood, and thus introducing the plotline of the film, namely the upbringing of the motherless Luca (Charlie Lucas/Baird Wallace) by the group of ladies. **↝Barbara Garbin**

Photo © Valeria Castelli

Directed by Franco Zeffirelli
Scene description: The Scorpioni visit the grave of Elizabeth Barrett Browning
Timecode for scene: 0:01:35 – 0:04:46

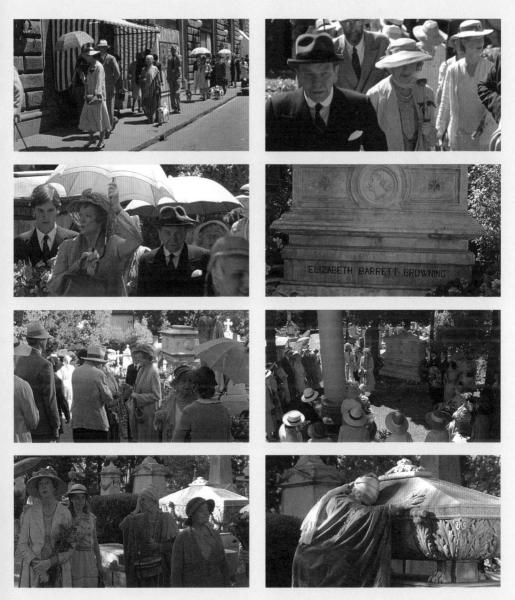

Images © 1999 Medusa Produzione, Cattleya, Cineritmo, Film and General Productions Ltd

UP AT THE VILLA (2000)

Orsanmichele

SET IN 1938 following the notorious Munich Agreement, the noirish melodrama *Up at the Villa* chronicles Mary Panton's (Kristin Scott Thomas) encounters with three men, who vie for her heart while Europe is on the brink of war. Although one expatriate exclaims, 'everyone knows that Florence in the safest city in Europe', references to fascism, Nazism, concentration camps and deportations ground the film in a traumatic historical moment. The brief early scene when Mary and Sir Edgar Swift (James Fox) traverse the streets of Florence by night establishes the tone of suspense and intrigue that pervades the film. The pair looks warmly at one another as they drive on the historic Via dei Calzaiuoli by the fourteenth-century Church of Orsanmichele that is lit by torches and adorned with fourteen patron saints of various guilds. However, the serenity and security of the moment, underlined by a shot of a sculpture of St Peter watching over the couple, is disrupted when two belligerent Italians assault the car, which prompts Sir Edgar to gift Mary a gun. Indeed, halfway through the film, one of Mary's suitors uses the gun to kill himself in front of her. In the end and cleared of guilt, Mary chooses adventure over the security of a loveless marriage offered to her by Sir Edgar and follows her heart to pursue the debonair playboy Rowley Flint (Sean Penn). However, concluding images of Fascists walking through the Florence train station remind the viewer that love does not conquer all. **↦Dana Renga**

Photo © Alberto Zambenedetti

Directed by Philip Haas
Scene description: On the eve of Sir Edgar's proposal to Mary,
the pair drive through the streets of Florence at night
Timecode for scene: 0:05:44 – 0:06:06

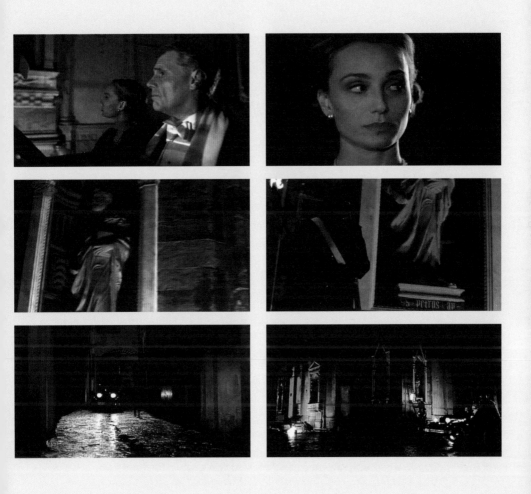

HANNIBAL (2001)

Piazza della Repubblica

IN HANNIBAL, director Ridley Scott transforms Florence into a gloomy hideout for Hannibal Lecter (Anthony Hopkins), the cannibalistic serial killer from *The Silence of the Lambs* (Jonathan Demme, 1991). The city becomes a confounding maze of narrow streets and alleyways, with Lecter drifting ominously from one locale to the next, undetected. *Hannibal* is set ten years after *The Silence of the Lambs* with Lecter living in relative obscurity. Eventually, the curious local inspector Pazzi (Giancarlo Giannini) recognizes him on the FBI's ten most-wanted list and realizes there is a seven-figure reward for the fugitive's capture, courtesy of one of Lecter's most vindictive victims, the wealthy and disfigured Mason Verger (Gary Oldman). Many Florentine scenes either initiate in or traverse the porticoed arches of Piazza della Repubblica; an open space at the heart of the city's historic district. In one chilling sequence, Pazzi hires a pickpocket to follow Lecter through the streets in order to acquire a set of his fingerprints. Scott casts long shadows over the marble walkways of the piazza's towering arches, shrouding the pursuit in a foggy chiaroscuro. The chase ends with the pickpocket's graphic murder at Lecter's hands in the Loggia del Mercato Nuovo, followed thereafter by Pazzi's own grisly death-by-hanging in the Piazza della Signoria. Throughout, Scott achieves a disquieting atmosphere of dread and suspense that mirrors the macabre story that unfolds, foreshadowing Lecter's dark reunion with Clarice Starling (Julianne Moore) that concludes the film.✤ ***Brendan Hennessey***

Photo © Alberto Zambenedetti

Directed by Ridley Scott
Scene description: A pickpocket pursues Hannibal Lecter
Timecode for scene: 0:54:48 – 0:59:26

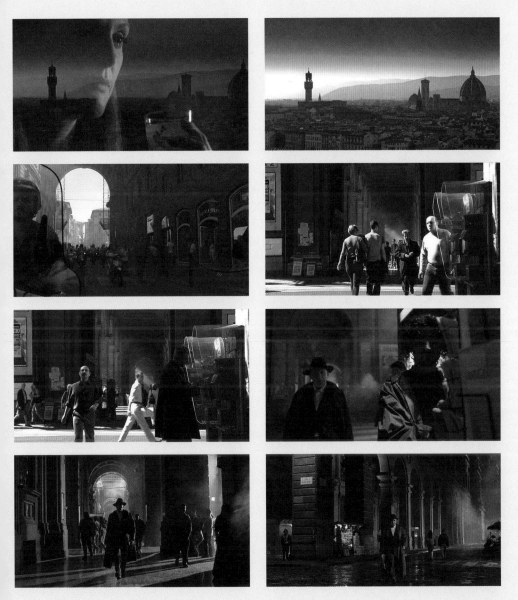

Images © 2001 MGM, Universal, Dino De Laurentiis

FROM DANTE TO MACHIAVELLI

Text by
BARBARA
GARBIN

Canonical Florentine Literature on Film

AS THE CRADLE of Italian Renaissance, Florence was the birthplace of some of the most prominent authors of early Italian literary masterpieces. It comes as no surprise, then, that Italian cinema has paid frequent homage to the fathers of the nation's literature with cinematic adaptations, allusions or tributes to their work. Dante Alighieri's *Divine Comedy* (1308–21) undoubtedly exerted the most influence, particularly in cinema's early years, mostly for two reasons: first, the prestige of Dante's work was expected to transfer to the new medium, still seen more as a spectacle than an art; second, Dante's significance as national icon made his work quintessential in promoting a national cinema. Between 1908 and 1912, eleven films based either on *The Divine Comedy,* selected episodes (Francesca from Rimini, Pia de' Tolomei and Conte Ugolino) and Dante's life were made. The most significant was certainly 1911 *L'inferno/ Dante's Inferno*, the first Italian feature or multi-reel film, directed by Adolfo Padovan and

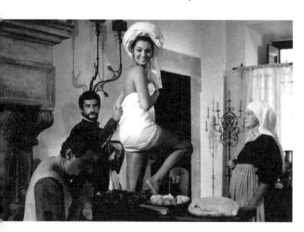

Francesco Bertolini, and produced by Milano Films. *Dante's Inferno* narrates Dante's journey in Hell, through some of its more recognizable moments and characters. In its iconography, the film closely follows the engravings of French artist Gustave Doré (1832–83), which first appeared in the 1861 edition of *Inferno*, and have since enjoyed a huge popularity. The film was also a collection of special effects and technical tricks à la Méliès that granted it international success, earning more than $2 million in the United States alone. In 1911, a small production company in Velletri, Helios Films, also released a version of the *Inferno,* which was immediately followed by a *Purgatory.* In 1912 the newborn Psiche Film produced an adaptation of Dante's *Paradise*. Reviews and promotional materials suggest that the three films were subsequently distributed together as one single 'super feature' film, although no complete copy survives.

Whereas in Italy Dante's *Comedy* was adapted as a narrative per se, abroad it was mostly incorporated within extended and current plotlines. In 1924, Henry Otto directed for Fox Film Corporation an American production titled *Dante's Inferno*. The storyline was contemporary and the visual references to Dante's hell were instrumental to the moralistic purpose of the film. The villain, an unscrupulous millionaire, is taken into a lengthy dream to hell. The director selected a few specific scenes from Dante's vision to enhance the film's educational goal, reminding the sinful businessman of his path to perdition. Critics and audiences seemed to enjoy mostly the amazing pictorial effects, which followed very closely Gustave Doré's famous illustrations of *The Divine Comedy*. In 1935, director Harry Lachman also used imagery from Dante's poem to enhance

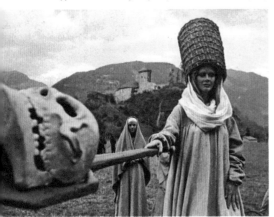

He also maintained only middle- and lower-class protagonists, and substituted the Florentine vernacular with Neapolitan street talk in line with his interest in Italy's linguistic variety. The film was one of the highest-grossing films of 1971; moreover, with its explicit eroticism, it inspired an entire sub-genre of sequels, mostly erotic or soft-porn films vaguely related to Boccaccio's masterpiece.

While Pasolini's *The Decameron* is certainly the most famous, it was not the first adaptation of a selection of Boccaccio's stories for the big screen. In Hugo Fregonese's 1953 *Decameron Nights*, Boccaccio (Louis Jourdan) follows his beloved Fiammetta (Joan Fontaine) and other six women in a villa in the countryside. He courts her by telling three of the Decameron's famous love stories, featuring Jourdan as the romantic male lead and Joan Fontaine as the misunderstood and mistreated woman. Joan Collis also appears as Pampinea, one of the ladies of Fiammetta's entourage. In combining elements form the author's fictionalized biography and the novellas, screenwriter George Oppenheimer offers a less erotic version of Boccaccio's masterpiece than Pasolini's. In 1924, American director Fred Wilcox directed an English-German film of the same title, based on a highly popular play by Robert McLaughlin, that was in itself an adaptation of Boccaccio's material. Lionel Barrymore plays a sultan whose son falls hopelessly in love with a Muslim princess. For its magnificent sets and crowd scenes, the film was a great success both in the United States and the United Kingdom.

Within a general return of interest in cinematic adaptation of literary works, in 1965 Italian director Alberto Lattuada made into a film Niccolò Machiavelli's brilliant and sarcastic comedy *La Mandragola* (1519). Lattuada's rendition follows rather faithfully Machiavelli's story of a young Florentine gentleman, Callimaco (Philippe Leroy) who falls in love for Lucrezia (Rosanna Schiaffino), the beautiful and faithful wife of the old and laughable Messer Nicia Calpucci (Romolo Valli). Thanks to the ingenuity of his servant Ligurio (Jean-Claude Brialy), the opportunism of Lucrezia's mother Sostrata (Nilla Pizzi) and the greediness of her confessor Fra' Timoteo (Totò), the man is able to conquer Lucrezia and at the same time befriend her husband Nicia. Lattuada's emphasis on the eroticism of the story rather than its wittiness left most of the critics dissatisfied. Notwithstanding, Totò's performance in the supporting role of Fra' Timoteo was highly applauded. ✢

the moralistic message of his narrative: his *Dante's Inferno* is set in the present-day era and follows the life of an ambitious and ruthless entrepreneur, Jim (Spencer Tracy), who runs a fair ground concession known as 'Dante's Inferno'.

Spencer William's *Go Down Death* (1944) deserves s special mention: in line with Otto and Lachman's adoption of Dante's infernal scenes as cues for eternal punishment, the African American director physically 'cut and pasted' clips from the Italian 1911 *Dante's Inferno* film to depict a trip to hell for his main character's soul. Williams selected only a limited number of frames, amounting to less than one minute in running time, but the result is that Dante is the only white character in the movie.

Another illustrious Florentine literate was Giovanni Boccaccio (1313–70), whose *Decameron,* a collection of 100 novellas, became the inspiration for many works of literature, theatre and cinema. The most famous adaptation of Boccaccio's *Decameron* is unquestionably Pier Paolo Pasolini's 1971 *Il Decameron / The Decameron* , the first film in the Trilogy of Life, which he dedicated to medieval literature – the other two being *I racconti di Canterbury / The Canterbury Tales* (1972) and *Il fiore delle mille e una notte / Arabian Nights* (1974).

Pasolini's *Decameron* departs significantly from its literary source. The Italian director eliminated the original narrative frame used by Boccaccio (an epidemic of Black Death), and selected only ten stories, favouring erotic contents.

While Pasolini's Decameron is certainly the most famous, it was not the first adaptation of a selection of Boccaccio's stories for the big screen.

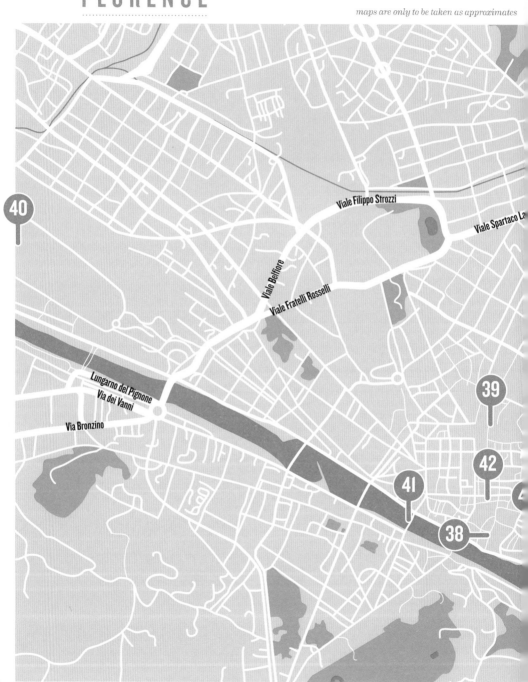

FLORENCE LOCATIONS
SCENES 37-43

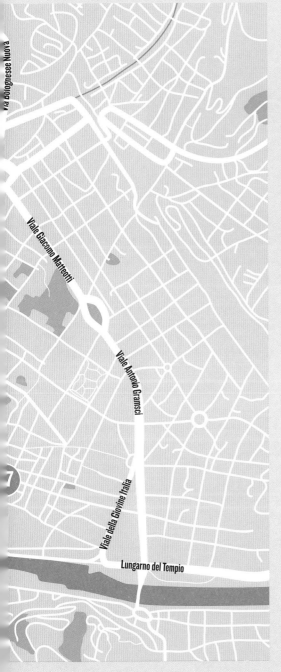

CIAO AMERICA (2002)

LOCATION *Piazza di Santa Croce*

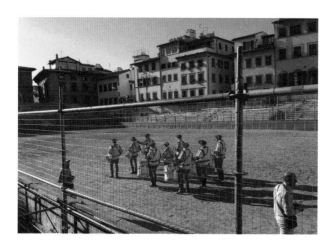

IN THE ROMANTIC COMEDY *Ciao America*, Lorenzo Primavera (Eddie Malavarca) travels to Italy to explore his heritage. Before too long, he is coaching an Italian *football* team in Ferrara, has a steady girlfriend and an Italian passport, has connected with his recently departed grandfather's relatives and must make a life-changing decision: to follow his heart and remain in Italy with the penalty of serving obligatory military service, or return home and pursue capitalist enterprise. In the end, he listens to the voice of his grandfather and chooses love over wallet, and surprises Paola (Violante Placido) when dressed in his *carabiniere* garb on the steps of Santa Croce as she represents her mother's *contrada* (neighbourhood of Florence) during the ritual of *calcio storico*, the Florentine predecessor to football originating in the sixteenth century. In opting for the Italian over the American dream, Lorenzo makes up for his grandfather's mistake of leaving his family in Avellino to immigrate to America in search of a better life. After the pair is united, we watch a game of *calcio storico* in the Piazza Santa Croce and the film concludes as, through voice-over, Lorenzo realizes that his grandfather only desired his happiness. Thus, and in keeping with the genre of melodrama, happiness in *Ciao America* implies sacrifice: Lorenzo must give up his own dreams (independence and freedom) to settle down and serve his new country. To say goodbye to America then means to embrace an Italy steeped in nostalgia and governed by traditional gender roles. ⟶ ***Dana Renga***

Photo © Alberto Zambenedetti

Directed by Frank Ciota
Scene description: Lorenzo and Paola are reunited and then a game of calcio storico takes place
Timecode for scene: 1:33:38 – 1:35:22

THE BEST OF YOUTH/LA MEGLIO GIOVENTÙ (2003)

LOCATION *Piazzale degli Uffizi*

ON 4 NOVEMBER 1966 (the 48th anniversary of Italy's victory in World War I), Florence's Arno river flooded the city, leaving dozens dead and causing irreparable damage to artworks in the Uffizi Gallery and to thousands of ancient books and manuscripts stored in the archives of the National Library. The loss was mitigated by the intervention of the (best of) Italian youth, who converged on Florence en masse to help dig precious artefacts out of the mud. In Marco Tullio Giordana's family epic, spanning the years from the early 1960s to 2003, these 'angels of mud', as they were called, are paid tribute to in a meaningful segment. Several social types who would be at each other's throats come the 1970s are seen working together for the sake of a shared national patrimony: the army recruit and future angry cop, the progressive but moderate university student, the future star economist, and the soon to become leftist terrorist. Released on the wake of a troubling resurgence of political terrorism in Italy, the film carries a conciliatory and unifying message, most evidently in this image of Italians coming together at a time of crisis. It is a reference to the purported inclusiveness and heterogeneity of the anti-Fascist Resistance of 1943–45, the 'good fight' whose violence the streets of Florence had seen a great deal of and whose insurrectionist ethos would later be revived, though now in the name of national disunity, by the political ideology of the Italian terrorist left. **◆Stefano Ciammaroni**

Photo © Alberto Zambenedetti

Directed by Marco Tullio Giordana
Scene description: Marco and Matteo reunite as they join the
'angels of mud' after the flood of 4 November 1966
Timecode for scene: 1:16:06 – 1:19:56

Images © 2003 Tonino Nieddu and Fabrizio Zappi for RAI Fiction, Angelo Barbagallo for Bibifilm TV

UNDER THE TUSCAN SUN (2003)

LOCATION *Piazza del Duomo*

THE FLORENCE OF TOURS and foreign tourism becomes a gateway to a new life for the writer Frances (Diane Lane), the lead character in *Under the Tuscan Sun*. For Frances, the city is the first stop in an extended visit, a world distant from her native San Francisco and the divorce that has left her lost and unable to write. Film-maker Audrey Wells captures her integration with Florence's many foreign visitors in a shot of Frances exiting the tour bus to a packed Piazza del Duomo. The camera pans up from a bevy of multi-coloured umbrellas to capture the Duomo and the Campanile – two of Florence's most iconic visitor attractions. Her identity as a foreign tourist in Italy, however, is short lived, as Frances decides to live out the fantasy of many visitors who wish to make their stay a permanent one. Refurbishing an aged villa outside of Cortona brings her in contact with a temporary lover Marcello (Raoul Bova) and a group of Polish immigrants who become her friends. After a return to Florence for the birth of her American friend Patti's (Sandra Oh) daughter, Frances's surrogate family continues to grow, marking a new, happier stage to come. **⊷Brendan Hennessey**

Photo © Alberto Zambenedetti

Directed by Audrey Wells
Scene description: Frances exits the tour bus into Piazza del Duomo
Timecode for scene: 0:14:08 – 0:14:30

Images © 2003 Touchstone, Timnick Films, Blue Gardenia, Tatiale Films

MAR NERO (2009)

Parco delle Cascine

MAR NERO TACKLES the immigration issue from the perspective of a young Romanian woman, Angela (Dorotheea Petre), who finds employment in Florence as a caregiver for the elderly Emma (Ilaria Occhini). Once in Italy, Angela balances her time between work and the local Romanian community. In particular, one scene portrays the Romanians' nostalgic gatherings at Cascine Park, where they get together to picnic, listen to music and chat. Originally established by the Medici family in 1564 as a private estate along the Arno River, the park later became public under the Habsburg-Lorraine dynasty, a collective and recreational function that has been maintained up to the present. The scene begins with a series of medium shots and long shots of Angela as she joins a circle of Romanian women amicably chatting on the grass. Interspersed with these are medium shots of a group of Romanian men laughing and drinking next to the women. What follows is a brief, romantic shot counter shot between Angela and a handsome man from that group, whom she sees for the first time. Finally, an extreme long shot of the park encompasses the gathering within a panoramic view of the Arno and the nearby railway, where a train slowly approaches Santa Maria Novella station. The scene thus suggests the Cascine's proximity to, and difference from, the rest of the city by emphasizing the park's role in providing Florentines and foreigners alike with a pleasant haven from the pressure and worries of city life. •◆**Marco Purpura**

Directed by Federico Bondi
Scene description: Angela joins the local community of Romanians
who gather at Florence's Parco delle Cascine
Timecode for scene: 0:23:39 – 0:25:29

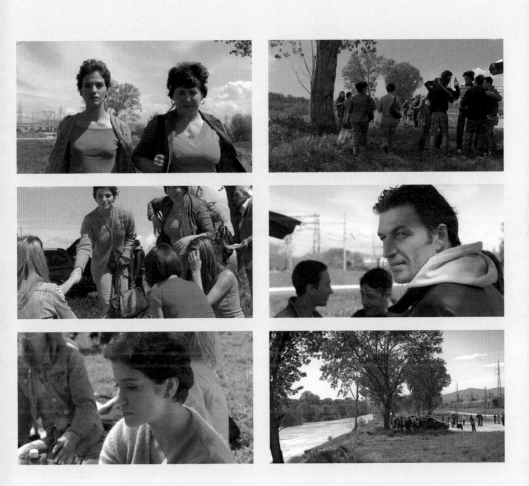

MIRACLE AT ST. ANNA (2009)

LOCATION *Ponte Santa Trinita in Florence, and Serchio River*

MIRACLE AT ST. ANNA was not filmed in Florence but 80 km away in the province of Lucca. The film is distinctly tied to the geography of Florence, however, as its narrative arc depends on an object gone missing from the city's Ponte Santa Trinita. While the bridge was destroyed in 1944, the head of the *Primavera* statue that once graced it remained unscathed. In Lee's film, this lucky relic allows key figures to survive. It also serves, in its official absence and special but largely unrecognized value, as an emblem of the buffalo soldiers themselves; the vital contributions of African American soldiers are notably missing in most histories of World War II. The relic is first introduced fifteen minutes into the film. A group of six soldiers advances toward screen left through fog and tulle. Private Sam Train (Michael Ealy) runs to the front. As the camera closes in on him, just over the shoulder of his commanding officer, Train is teased by cohorts for his nerves. He replies 'good luck charm giving me strength,' as the camera pans down his large frame to a stone head, gazing peacefully forward, in a mesh bag tied to his belt. Train reaches to pat it as a fellow officer chides: 'that piece of shit you found in the gutter in Florence. You couldn't pull a bowl of turtle soup [...] from that thing.' Train, shot in profile, turns indignantly to reply: 'It's worth more than a bowl of turtle soup!' Is it ever. **⊷Monica Seger**

Directed by Spike Lee
Scene description: A group of buffalo soldiers makes its way through a field toward the Serchio River
Timecode for scene: 0:15:15 – 0:15:48

WEDDINGS AND OTHER DISASTERS/
MATRIMONI E ALTRI DISASTRI (2010)

LOCATION *Armando Poggi store on Via dei Calzaiuoli*

THE SCENE OPENS on actress Margherita Buy's wide-eyed fragility
framed by exquisite glassware. Nanà scans the shelves of Armando Poggi's
prestigious store for her busy sister's wedding list, a task reluctantly taken
on with her brother-in-law to be. The status associated with Poggi's products
might suit the bourgeois family of Tuscan vineyard-owners, from which she
and her sister, Beatrice, originate. However, Nanà, a perennially sex-starved
singleton, is slightly older, less conventional and more intellectual than her
sister. Elsewhere in the shop, Beatrice's ambitious fiancé, Alessandro (Fabio
Volo), an improbable lothario and yuppie with designs on the family business,
leans across Poggi's counter to chat up a gullible shop assistant. As he
compares the assistant's eyes to the border gracing a porcelain plate, 'indigo
with a small hint of periwinkle,' Nanà interrupts acerbically to describe
the colour as a watery blue. She dismisses the plate as too old-fashioned
and grandiose for the wedding list, expressing her disapproval of the shop,
Alessandro's bourgeois aspirations and his sexual hypocrisy. Armando
Poggi is promoted as the two characters are framed exiting through the
conspicuously labelled glass shop doors, but Alessandro also comments on the
fact that Nanà has not found anything to her satisfaction there. Nanà's disdain
for bourgeois tradition and marriage, both unsettles Alessandro, and attracts
him. Eventually the two have a fleeting liaison that leaves a question mark
over the value of monogamy, which the white wedding industry, represented
by Poggi's store, and romantic comedy itself potentially reinscribe.
◦› Danielle Hipkins

Photo © Elizabeth Williams

Directed by Nina di Majo
Scene description: Nanà and Alessandro visit Armando Poggi
homeware shop to decide on a wedding list
Timecode for scene: 0:25:06 – 0:26:21

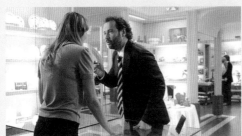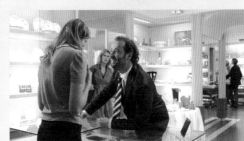

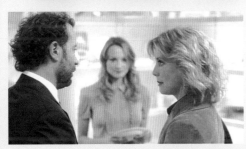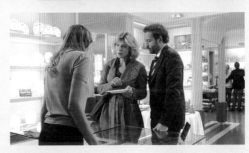

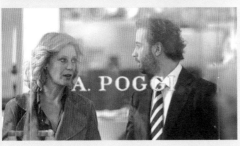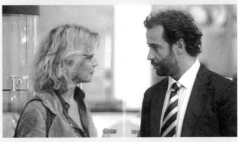

SOMETHING IN THE AIR/APRÈS MAI (2012)

LOCATION *Piazza dei Peruzzi*

SOMETHING WAS DEFINITELY in the air for those who came of age in the aftermath of the tumultuous events of May 1968 thinking that the revolution was at reach, through weapons as varied as the pistol, the painter's brush and the film-maker's camera. In 1971 Paris, Gilles (Clément Métayer) is a high school student committed to a career in abstract painting and left-wing insurrectionism. After his anti-establishment exploits draw police attention, Gilles is forced to seek refuge abroad. Appropriately, he lands in arty Florence, where his frequentations of the local radical collectives take him to an open-air screening of a French documentary on the Laotian Communists fighting the American military alongside North Vietnam. A typical, obligatory debate ensues on the need for a cinematic syntax 'at the service of the internationalist revolution' and the struggle 'to defy the imperialist forces'. With a touch of irony too delicious to dismiss as incidental, Assayas has this gathering of revolutionaries take place in and 'occupy' Piazza de Peruzzi, which in late medieval times had been the courtyard around which stood the residence of the Peruzzi family. Bankers, international traders and war profiteers, the Peruzzi helped King Edward III of England finance his imperialist endeavours in France and Scotland in exchange for economic favours. By the mid-fourteenth century, however, the cost of what would become known as the 'Hundred Years' War' proved unsustainable for the Peruzzi, whose bankruptcy is believed to have had a significant impact on the economic depression of the late Middle Ages. **Stefano Ciammaroni**

Photo © Elizabeth Williams

Directed by Olivier Assayas
Scene description: Gilles attends an open-air screening of a documentary
on the role of the Laotian Communists in the Vietnam War
Timecode for scene: 0:43:49 – 0:47:18

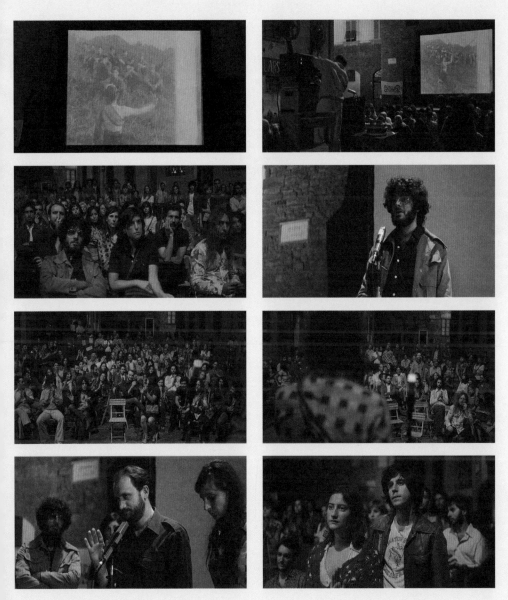

Images © 2012 Marin Karmitz, Nathanaël Karmitz, Charles Gillibert

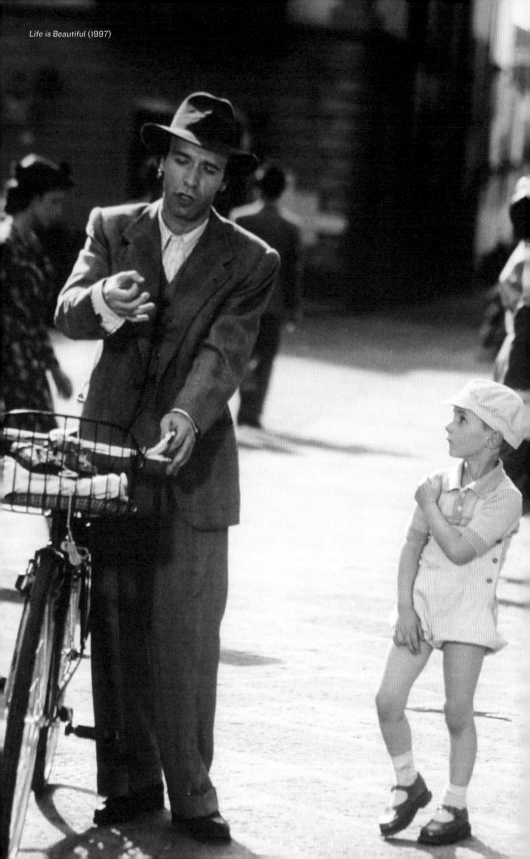

GO FURTHER

Recommended reading and useful web resources

BOOKS

Dante nel cinema
by Gianfranco Casadio (ed.)
(Longo Editore Ravenna, 1996)

Dante, Cinema, and Television
by Amilcare Iannucci (ed.)
(University of Toronto Press, 2004)

Firenze nel cinema
by Andrea Vannini
(Edizioni La Bottega del Cinema, 1990)

The Monster of Florence: A True Story
by Douglas Preston and Mario Spezi
(Grand Central Publishing, 2008)

Inferno
by Dan Brown
(Doubleday, 2013)

The Stones of Florence
by Mary McCarthy
(Harcourt, 1959)

The House of Medici: Its Rise and Fall
by Christopher Hibbert
(Harper Collins, 1974)

The Autobiography of Benvenuto Cellini
by Benvenuto Cellini
(Penguin, 2002)

History of Italian Renaissance Art
by Frederick Hartt & David Wilkins
(Pearson, 2010)

The Decameron
by Giovanni Boccaccio
(Random House, 2010)

The History of Florence
by Francesco Guicciardini
(Harper and Rowe, 1970)

Dominion of the Eye: Urbanism, Art and Power in Early Modern Florence
by Marvin Trachtenberg
(Cambridge University Press, 1997)

The Lives of the Artists
by Giorgio Vasari
(Oxford World's Classics 1991 [1550])

Murder Made in Italy: Homicide, Media, and Contemporary Italian Culture
by Ellen Nerenberg
(Indiana University Press, 2012; see in particular the chapter 'The "Monster" of Florence', pp. 23–53)

Racconti cinematografici
by Andrei Tarkovsky
(Garzanti Editore, 1994)

ARTICLES

Re-presenting the National Past: Nostalgia and Pastiche in the Heritage Film
by Andrew Higson (1993)
In Lester Friedman (ed),
British Cinema and Thatcherism
(UCL Press, 1993) pp. 109–129.

ONLINE

Andrei Tarkovsky interviewed by Natalia Aspesi (Cannes, 1983)'
(*La Repubblica*, 17 May 1983 [trans. David Stringari]) *http://bit.ly/1043lXM*

Abbracci e Popcorn
Several posts on films shot in Florence.
http://bit.ly/1iZSthg

Itinerari in Toscana
Devoted to promoting Tuscan culture.
http://bit.ly/1iZasVv

Toscana Film Commission
Official site of the Toscana Film Commission
http://www.toscanafilmcommission.it

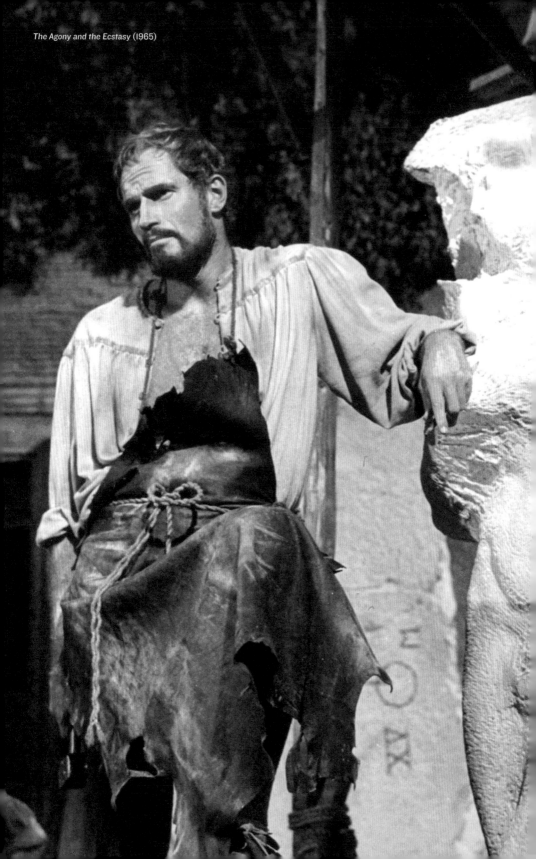

CONTRIBUTORS

Editor and contributing writer biographies

EDITOR

ALBERTO ZAMBENEDETTI is Visiting Assistant Professor of Cinema Studies and Mellon Postdoctoral Fellow at Oberlin College. His scholarship has appeared in various publications, such as *Short Film Studies, Journal of Adaptation in Film & Performance, Annali d'Italianistica* and *Studies in European Cinema*. He has also contributed to the Venice and Rome instalments in the World Film Locations series. Alberto regularly writes reviews and festival coverage for the online film magazine *Gli Spietati*.

CONTRIBUTORS

ELEANOR ANDREWS is Senior Lecturer in Italian and Course Leader for Film Studies at the University of Wolverhampton, UK where she teaches European Cinema. Her interest in Italian cinema includes neo-realism, the spaghetti western and the work of the director Nanni Moretti. She has published chapters on family life and authorship in Moretti's films. She has also worked on the Holocaust in film as well as film, myth and the fairy tale.

STEFANO CIAMMARONI is Senior Lecturer in Film and TV at Manchester Metropolitan University. He earned his PhD at New York University's Cinema Studies Department and has written on Italian neo-realism and the cinema of Pier Paolo Pasolini as well as, more recently, on the nascent intra-national cinema of Cebu, Philippines. His work on the politics of Italian horror director Dario Argento will be published next year in a special issue of the *Journal of Horror Studies*.

MARIE-FRANCE COURRIOL is a teaching assistant in Italian Studies at the Université Lille 3 (France), and a PhD student at Lille 3 in co-tutoring with the University of Cambridge (UK).

She previously obtained an MPhil in Screen Media and Cultures at the University of Cambridge. Her doctoral thesis examines documentary and realist strategies in Italian war films of the Fascist period.

NATHANIEL J. DONAHUE is an instructor of Art History at Santa Monica College. He completed his dissertation at New York University in 2013 and is currently at work on a book considering the relationship between Pierre-Auguste Renoir's late work and the history of avant-garde painting and sculpture. Professor Donahue's other interests include World's Fair and theme park architecture as well the relationship between the decorative arts and Modernism.

NATALIE FULLWOOD received her PhD in Italian cinema from the University of Cambridge, UK. Her research focuses on popular Italian cinema, especially comedy, and representations of gender and space. She is currently working on a monograph on everyday space and gender in Italian-style comedy which will appear with Palgrave MacMillan.

BARBARA GARBIN (PhD Yale, 2009) is Visiting Assistant Professor of Italian in the Foreign Languages and Literatures Department at Skidmore College. Her research interests include Italian women writers, fantastic literature and language teaching through films and other media.

BRENDAN HENNESSEY is a postdoctoral scholar in the Department of Romance Languages and Literatures at the University of Notre Dame. His research interests include Italian cinema, theatre and cultural studies, Italian American studies, and topics in the digital humanities. Currently, he is writing a monograph on director Luchino Visconti and exchanges between popular cinema and the dramatic arts in post-war Italy. He →

CONTRIBUTORS

Editor and contributing writer biographies (continued)

has taught at Notre Dame, UCLA, the University at Buffalo and Colby College.

DANIELLE HIPKINS is Associate Professor in Italian Studies and Film at the University of Exeter. She has published on post-war Italian women's writing, cinema and gender, and is currently working on *Italy's Other Women: Gender and Prostitution in Postwar Italian Cinema, 1942–1965* (forthcoming, 2014). She is also working on an AHRC-funded project on Italian cinema-going audiences of the 1940s and 1950s, and on contemporary cinema in the context of postfeminism.

DOM HOLDAWAY is Research Fellow at the University of Warwick, where he completed his PhD (in Italian Film) in 2012. His current research deals with political film and media in Italy, and specifically the function of performativity that takes place between audience and film-maker. He has also worked on urban space in film and culture widely, co-editing a volume entitled *Rome, Postmodern Narratives of a Cityscape* (Pickering and Chatto, 2013).

PASQUALE IANNONE is a film lecturer, writer and broadcaster. He teaches at the University of Edinburgh and contributes regularly to *Sight & Sound*, *Senses of Cinema* and BBC Radio. He is currently working on a book on Jean-Pierre Melville's *L'Armée des Ombres* for BFI/Palgrave.

CHARLES L. LEAVITT IV is Lecturer in Italian Studies at the University of Reading. He studies modern Italian literature and cinema in a comparative context. Leavitt earned his PhD in Literature from the University of Notre Dame, where he was Presidential Fellow in the Humanities, Annese Fellow of the Nanovic Institute for European Studies and Postdoctoral Research Fellow in Italian Studies.

ELLEN NERENBERG is Hollis Professor of Romance Languages and Literatures at Wesleyan University. She is the author of *Murder Made in Italy: Homicide, Media, and Contemporary Italian Culture* (Indiana University Press, 2012), *Prison Terms: Representing Confinement During and After Italian Fascism* (University of Toronto Press, 2001), and co-editor and translator of *Body of State: The Moro Affair, A Nation Divided* (Fairleigh-Dickinson University Press, 2011). She is completing a study of performance in and in relation to the works of Primo Levi.

JOSEPH PERNA is currently completing a PhD on film melodrama in the Department of Italian Studies at New York University. He is the author of 'Compositional Affect in Ophuls'' (*The Italianist*, 34:2, 2014), and his research interests include cinema and visual culture, spectatorship and public life, and theories of gender and sexuality.

MARCO PURPURA holds a PhD from the University of California, Berkeley in Italian Studies with a designated emphasis in Film Studies. His research focuses on the representations of immigration in Italian film and media. He has published articles in various journals, including the *Journal of Italian Cinema and Media Studies*, *California Italian Studies* and *Intersezioni*. Marco collaborates with *Balthazar:Polo di Studi sul Cinema*, Bergamo, and is currently working on a book manuscript based on his dissertation.

DANA RENGA is Assistant Professor of Italian and Film at the Ohio State University. She wrote *Unfinished Business: Screening the Italian Mafia in the New Millennium* (University of Toronto Press, 2013), edited *Mafia Movies: A Reader* (University of Toronto Press, 2011), and co-edits *The Italianist Film Issue*. She is working on a book called *Italian*

Women's Cinema and the Wounded Filmic Body (1915–2015) and the co-authored *A Long Holiday: Internal Exile in Fascist Italy* (with Elizabeth Laeke and Piero Garofalo, under contract, The University of Manchester Press).

JOHN DAVID RHODES is the author of *Stupendous, Miserable City: Pasolini's Rome* (University of Minnesota Press, 2007) and the editor of several books, including *Taking Place: Location and the Moving Image* (University of Minnesota Press, 2011, with Elena Gorfinkel) and *Antonioni: Centenary Essays* (Palgrave Macmillan, 2011, with Laura Rascaroli). He teaches film and literature at the University of Sussex and is a founding co-editor of the journal *World Picture*.

MONICA SEGER is Assistant Professor of Italian at the University of Oklahoma. Her work considers landscape, community and communication in contemporary Italian film and literature. She most enjoys Florence in the late afternoon, when buildings begin to cast long shadows and pedestrian pace begins to slow.

LUCA SOMIGLI is Associate Professor of Italian Studies at the University of Toronto. His research focuses on European modernism and on Italian genre fiction. A lifelong reader of comics, he is also the co-author of *Il cinema dei fumetti: Dalle origini a Superman Returns* (Gremese Editore, 2006), a history of film adaptations of comics.

SARA TROYANI is a doctoral candidate at the University of Notre Dame. Her research interests include travel and migration literature, Italian American and Italian Latin American studies, and Italian cinema. She is writing a dissertation that explores representations of Latin America in Italian emigration literature.

ROBERTO VEZZANI is a PhD student in Italian in the Department of Romance Languages and Literatures at the University of Michigan. He is developing a project on the circulation of Italian films in the United States during the 1930s.

CHRISTOPHER B. WHITE is a doctoral candidate in the Department of Italian at the University of California, Los Angeles. He received a BA in English from Kenyon College and a MA in Italian from the Middlebury College School in Italy. Christopher's research interests include post-war Italian cinema, the *commedia all'italiana*, and the films of Federico Fellini. He is completing a dissertation on Italian comic cinema of the 1950s and currently teaches at Ohio University.

CAMILLA ZAMBONI is a PhD candidate in the Department of Italian at UCLA. Her research focuses on Italian political film of the 1960s and 1970s, particularly on works by Elio Petri that address biopolitical concerns in the relationship between the state and the individual. Camilla has recently translated Elio Petri's *Writings on Cinema and Life* (Contra Mundum Press, 2013), and she contributed to he English edition of *Investigation of a Citizen above Suspicion* (Elio Petri, 1970), released by Criterion Collection.

WORLD FILM LOCATIONS
EXPLORING THE CITY ONSCREEN

ATHENS

Edited by Anna Poupou, Afroditi Nikolaidou and Eirini Sifaki
ISBN 9781783203598
PB £15.50 / $22

SINGAPORE

Edited by Lorenzo Codelli
ISBN 9781783203611
PB £15.50 / $22

SYDNEY

Edited by Neil Mitchell
ISBN 9781783203628
PB £15.50 / $22

BUENOS AIRES

Edited by Santiago Oyarzabal and Michael Pigott
ISBN 9781783203581
PB £15.50 / $22

RECOMMENDED BY
THE WORLD'S LEADING
FILM CRITICS...

GLASGOW

**Edited by
Nicola Balkind**

ISBN 9781841507194
PB £15.50 / $22

CHICAGO

**Edited by
Scott Jordan Harris**

ISBN 9781841507187
PB £15.50 / $22

MARSEILLES

**Edited by
Marcelline Block**

ISBN 9781841507231
PB £15.50 / $22

VANCOUVER

**Edited by
Rachel Walls**

ISBN 9781841507217
PB £15.50 / $22

LIVERPOOL

**Edited by
Jez Conolly and
Caroline Whelan**

ISBN 9781783200269
PB £15.50 / $22

BARCELONA

**Edited by
Helio San Miguel and
Lorenzo Torres J.
Hortelano**

ISBN 9781783200252
PB £15.50 / $22

PRAGUE

**Edited by
Marcelline Block**

ISBN 9781783200276
PB £15.50 / $22

HONG KONG

**Edited by
Linda C. Lai and
Kimburley Choi**

ISBN 9781783200214
PB £15.50 / $22

Find us on Facebook

For further information and to order books visit: **www.intellectbooks.com**

FILMOGRAPHY

All films mentioned or featured in this book

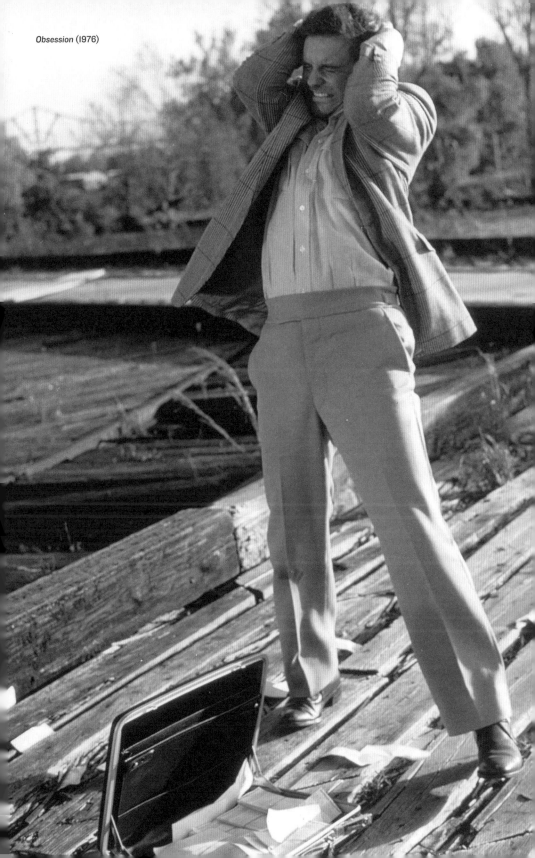

Obsession (1976)

WORLD
FILM
LOCATIONS
EXPLORING
THE CITY
ONSCREEN

www.intellectbooks.com